POSTCARD HISTORY SERIES

Jacksonville

IN VINTAGE POSTCARDS

*Between the Great Fire
and the Great War*

Jacksonville Postcards from 1901 to 1914

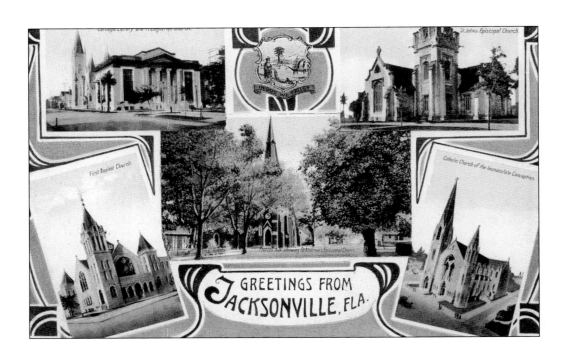

Carnegie Library and Presbyterian Church. St. Johns Episcopal Church. First Baptist Church. Catholic Church of the Immaculate Conception. Church Ave. showing St. Andrews Episcopal Church.

GREETINGS FROM JACKSONVILLE, FLA.

POSTCARD HISTORY SERIES

Jacksonville

IN VINTAGE POSTCARDS

*Between the Great Fire
and the Great War*

Jacksonville Postcards from 1901 to 1914

The Jacksonville Historical Society

ARCADIA

Published by Arcadia Publishing
Charleston SC, Chicago IL, Porstmouth NH, San Francisco CA

Printed in the United States of America

Library of Congress Catalog Card Number: 20010189120

For all general information contact Arcadia Publishing at
Telephone 843-853-2070
Fax 843-853-0044
E-mail sales@arcadiapublishing.com
For customer service and orders
Toll-Free 1-888-313-2665

Visit us on the Internet at www.arcadiapublishing.com

DEDICATION

The Jacksonville Historical Society is privileged to benefit from the knowledgeable, creative, and tireless efforts of a director nonpareil. This book is affectionately dedicated to

Emily Retherford Lisska

Emily Lisska edited and provided commentary for much of this book, which—like most Jacksonville Historical Society projects—simply would not have happened without her.

CONTENTS

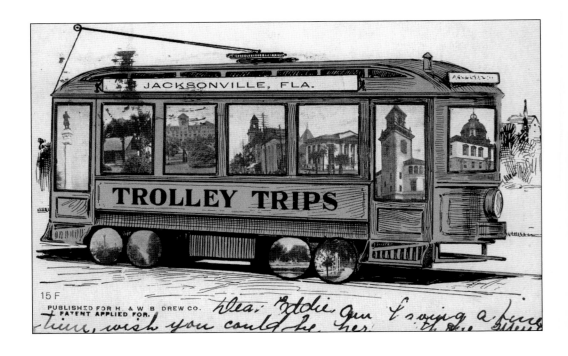

ACKNOWLEDGMENTS

This book could not have been produced without constant reference to Dr. Wayne W. Wood's work, *Jacksonville's Architectural Heritage, Landmarks for the Future* and to T. Frederick Davis's *History of Jacksonville, Florida*.

Bob Basford, a 1960 graduate of Robert E. Lee High School and now a resident of Woodstock, Georgia, donated many of the postcards included here as well as editorial insight. Joseph W. Ripley Jr., a Jacksonville Historical Society board member and lifelong Jacksonville resident, provided significant postcards from his family collection and chapter commentary. Shannon Jeter Gridley, a 1959 graduate of Alfred I. duPont High School, now living in Winter Park, Florida, also provided many cards used in this collection. Vicki L. Cummins, formerly of Pittsburgh but now a true Jacksonville resident, provided invaluable computer and editorial expertise.

Deanne M. Clark furnished much help and understanding. Thank you.

William H. Jeter Jr., editor
President, Jacksonville Historical Society
1999–2000

INTRODUCTION

Jacksonville's Great Fire on May 3, 1901, marked the end of Jacksonville and, at the same time, its beginning. The city's center was devastated; 466 acres burned, and nearly 9,000 people were left homeless. Homes, hotels, office buildings, and trees alike burned to the ground. The fire could be seen in Savannah and the smoke in Raleigh, North Carolina. It was the largest fire, both in area and property loss, ever experienced by any Southern city of the United States.

Very little remained of Jacksonville, before then a thriving port and a tourist and business center. Nevertheless, the city's rebuilding commenced immediately. Inspired by the opportunity to create a "20th century city" from the rubble, many prominent and aspiring architects flocked to Jacksonville. A building boom literally began before the ashes from the Great Fire cooled; reconstruction continued until approximately 1914, when downtown construction began to ebb.

This construction slow-down occurred contemporaneously with the outbreak of World War I, the "Great War." Although fought overseas, World War I forever changed America, along with all of Western civilization. Over 1 million British soldiers died on the battlefield, 1.7 million French, 1.5 million soldiers of the Hapsburg Empire, 2 million Germans, 460,000 Italians, 1.7 million Russians, and hundreds of thousands of Turks, who were never properly counted. The United States did not enter the war until June of 1917, when Gen. John J. Pershing and his troops arrived in France. America's casualties were correspondingly lower than any other country's troops to enter the war. Nevertheless, 48,000 Americans died. Among the dead were 1,200 Floridians; their sacrifices are commemorated at Memorial Park in Jacksonville's Riverside Area.

World War I forever altered the way wars were fought. "Civilized" warfare gave way to mechanized ferocity and mass death. The Western world's philosophies were also changed. The Victorian era ended, and modern art, psychology, medicine, and economics emerged.

From 1901 to 1914, Jacksonville's population increased from 28,429 to more than 85,000. More than 13,000 buildings were constructed in the city. Jacksonville's era of reconstruction and growth between the Great Fire and the Great War did much to define the city's present personality. During that same era, Americans (including Jacksonville citizens) ardently pursued a romance with postcards.

Postal correspondence originally consisted only of message-bearing paper inserted in stamped envelopes. The use of the words "Post Card" (often combined into the single word, "Postcard") was first granted by the United States government to private printers on December 4, 1901. Before then, there were "pioneer" postal cards that were permitted to traverse the mails within somewhat restrictive guidelines.

Many historians date the origins of the modern postcard to the Columbian Exposition, which was held in Chicago, Illinois, in 1893. The Columbian Exposition featured government printed cards (which contained a printed one-cent stamp) and privately printed souvenir cards (which required that a two-cent adhesive stamp be affixed to each card).

For some years after the Columbian Exposition, the use of "private mailing cards," as they were then called, was limited. No message writing was permitted on the address side of the card; however, some publishers left a margin or border on the "view side" of the card for a limited message.

In 1901, private citizens began to take black-and-white photographs and have them printed with postcard backs. Such cards are known as "real photo" cards, and they joined the cards published into circulation by commercial printing houses. The best commercial cards were printed in Germany, which then had lithographic expertise far superior to that of America.

Up until 1907, all postcards were of the "undivided back" variety; that is, only the address could be written on the back. On March 1, 1907, the so-called "divided back" postcard was permitted. A vertical line could be printed down the middle of the postcard's reverse side; and the recipient's address was written to the right of the vertical line. The stamp continued to be placed in the upper right corner of the card's reverse side. The left portion of the card's reverse side was then available for written messages.

Many tourists poured into Jacksonville aboard Henry Flagler's railroad (see page 22).

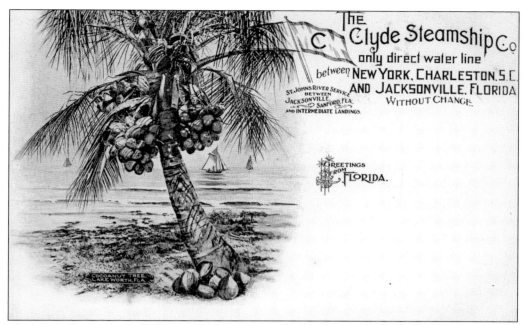

The Clyde Line (see pages 16–19) transported tourists by the thousands to Jacksonville and up the St. Johns River. This c. 1905 postcard promises Northern travelers tropical solace from frigid climes.

Millions of postcards were printed between 1907 and 1914. Collectors avidly traded and saved cards of every description. Almost every conceivable image was depicted on a postcard. Collectors were widespread and enthusiastic. Many cards were placed in collections without ever enduring the perils of the United States Post Office.

As a popular and populous destination—the "Gateway City" to Florida—Jacksonville was the subject of thousands of views. Jacksonville scenes are depicted on postcards published by the Detroit Publishing Company, the Rotograph Co. (New York) and by other "national companies." Local publishers, such as the H. & W.B. Drew Company, also published many cards. The H. & W.B. Drew Company continues in business (as stationers) to the present day, and, at nearly 150 years of age, holds the title of "Jacksonville's Oldest Business."

With the start of World War I, most postcard printing shifted from Germany to the United States. The high cost of labor, inexperience, and public taste resulted in the deterioration of postcard quality after 1914. From 1915 to 1930, a border was left around the perimeter of the card's view side to save ink. These postcards are consequently known as "white border" cards. Beginning in 1930, new printing processes were developed, and postcards were printed on paper with a high-rag content. These inexpensive cards had a "linen" finish and were brightly colored with gaudy dyes. The "Linen Era" ended about 1944. From 1945 to the present, most postcards have been printed using the photochrome process. These "chrome" postcards had their origins in 1939, when Union Oil Company distributed them as promotions.

This volume will showcase a fractional sample of Jacksonville postcards printed between the Great Fire and the Great War. This interval was simultaneously the "Golden Era of Postcards." While this collection does not presume to be comprehensive, it does aspire to provide the reader a slice of Jacksonville's rich cultural life at the beginning of the last century.

One

ON THE WATERFRONT

*T*he St. Johns River is Jacksonville's "Sine qua non." First Indians, then explorers and settlers, availed themselves of the convenient river-crossing point that became Jacksonville. By 1890, a railroad bridge crossed the river; however, the first automobile bridge was not constructed until 1921. Ferries and other marine craft were the lifeblood of Florida's economy before grudgingly giving way to the rail and the motor vehicle. It is no coincidence that many early postcards featured Jacksonville's thriving waterfront.

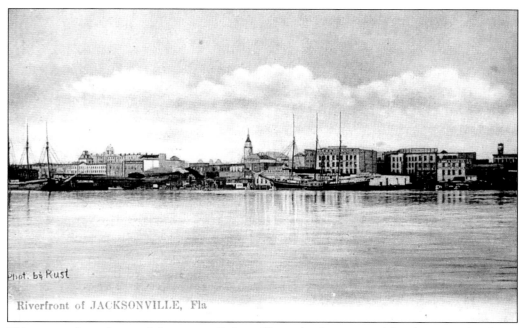

Phot. by Rust

Riverfront of JACKSONVILLE, Fla

This serene view of turn-of-the-century Jacksonville masks the commercial and construction boom that permeated the city and its port between 1901 and 1914. Jacksonville photographer O. Rust, who provided many local shots to postcard publishers, took this photograph.

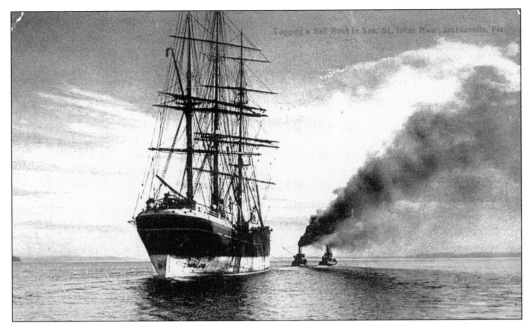

At the beginning of the last century "Tall Ships" could still economically carry cargo and passengers. Motor craft assisted sailing ships through the difficult St. Johns River channel during the last miles to downtown Jacksonville. This card was published by Jacksonville's H. & W.B. Drew Company.

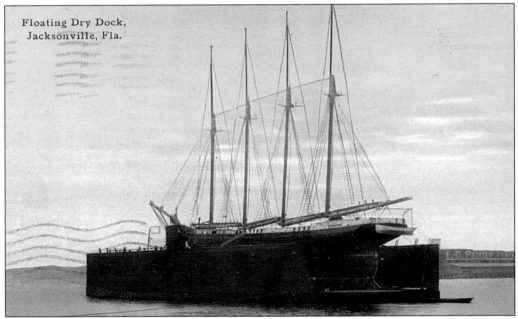

By the late 1880s, Jacksonville's Merrill-Stevens Co. had become one of the largest ship building companies in the South. Some 25 ships were built by that company for the World War I effort. This 1912 postcard depicts a floating dry dock that provided the Port of Jacksonville the ability to offer major repairs and overhauls to ships of all sizes.

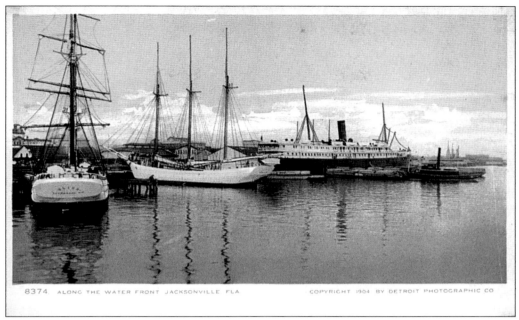

8374 ALONG THE WATER FRONT JACKSONVILLE FLA COPYRIGHT 1904 BY DETROIT PHOTOGRAPHIC CO

This undivided back postcard dates from about 1906. It shows the mixture of sail and steam craft that frequented Jacksonville during this era. (Courtesy Bob Basford.)

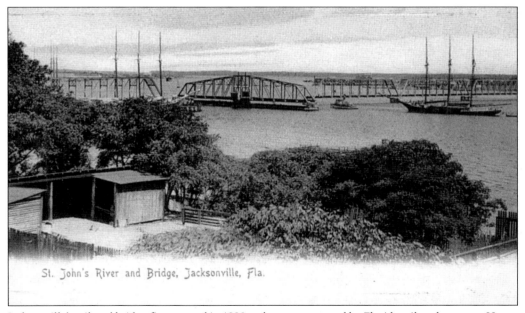

St. John's River and Bridge, Jacksonville, Fla.

Jacksonville's railroad bridge first opened in 1890 and was constructed by Florida railroad magnate Henry M. Flagler. Flagler previously transported his railroad cars across the St. Johns River by steam ferry. By providing more convenient access to South Florida, the bridge dissolved one of Jacksonville's last holds on the tourist industry. The pictured bridge was replaced in 1925. That bridge is still operational, and lies adjacent to the new St. Elmo W. Acosta Bridge.

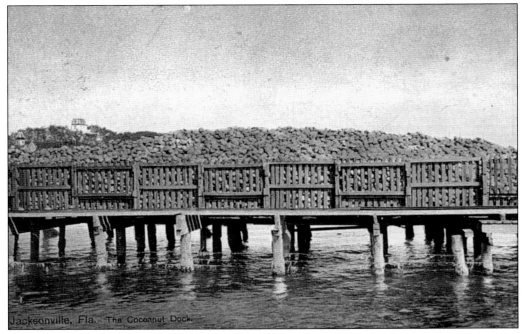

This 1909 card depicts "The Cocoanut Dock." The caption on the reverse side reads, "Many years ago the Spanish Brig 'Providencia,' cocoanut laden, was cast away off the Florida coast, and the cocoanuts were washed ashore to find congenial climate and soil for reproductive growth. Today the nuts form a considerable item of export through the port of Jacksonville. The cocoanut wharf is one of the sights of the city."

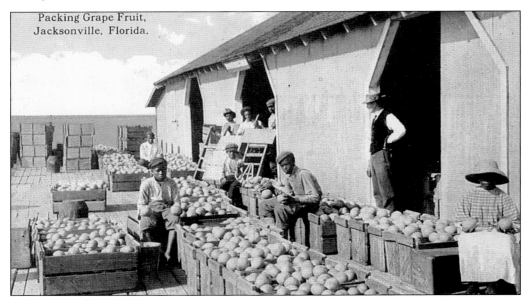

Dockworkers pack grapefruit for shipment from Jacksonville's bustling port, c. 1913. Steamships plied the St. Johns River and picked up citrus for delivery from groves in places such as Mandarin. The citrus was distributed northward by rail or by boat from Jacksonville. (Courtesy Bob Basford.)

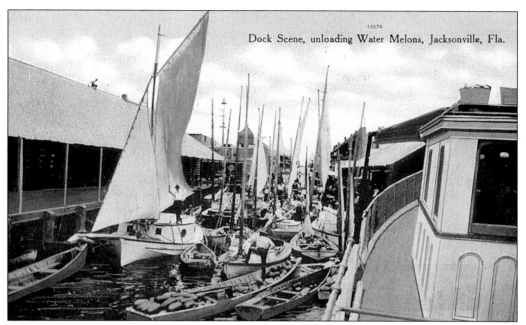

Watermelons were cultivated in abundance in the farm areas around Jacksonville. Farmers transported their crops to Jacksonville by whatever means were most convenient. (Courtesy Bob Basford.)

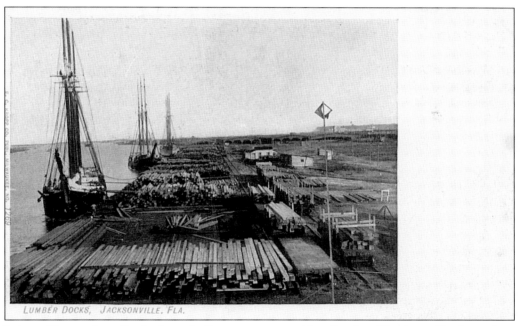

Jacksonville served as a distribution point for enormous quantities of lumber. The pictured loads may have originated at the Cummer Lumber Mill, built on the St. Johns River in 1896 by Wellington Cummer and his two sons. Before then, the Cummer family had engaged in the lumber business for more than 100 years in Canada. Cummer family interests still control large forest and undeveloped holdings in the Jacksonville area.

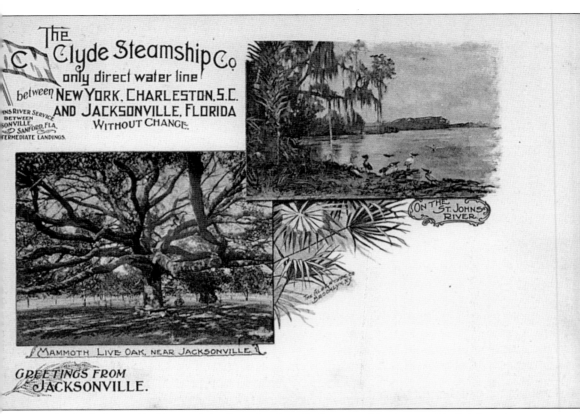

The Clyde Steamship Co
only direct water line
between NEW YORK, CHARLESTON, S.C.
AND JACKSONVILLE, FLORIDA
WITHOUT CHANGE.

ON THE ST. JOHNS RIVER.

MAMMOTH LIVE OAK, NEAR JACKSONVILLE.

GREETINGS FROM JACKSONVILLE.

The Clyde Steamship Lines and the Great Southern Railway combined to provide freight and passenger service. One could travel from New York to the West Indies, Florida, the Southeast United States, Mexico, and as far west as Colorado. The first Clyde Steamer, *Cherokee*, steamed into Jacksonville on November 18, 1886. Large crowds celebrated her arrival, and gun salutes were fired. The Clyde Line added other steamers over the years, including the *Algonquin*, the *Iroquois*, and the *Comanche*. This Clyde Line promotional postcard shows pelicans along the banks of the St. Johns River, as passengers might have viewed them from the decks. The card also depicts the "Treaty Oak."

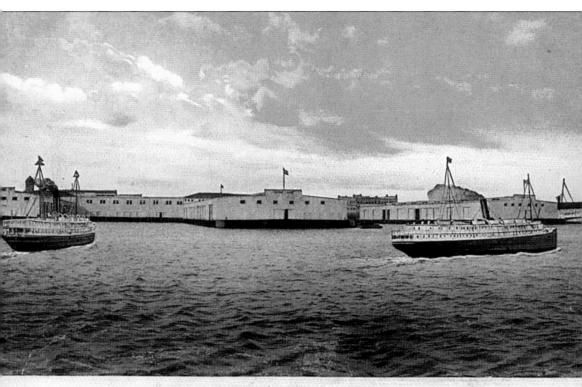

New Clyde Line Docks, Jacksonville, Fla.

In May 1911, a new Clyde Line terminal was opened to the Jacksonville public. The terminal contained two large sheds, each with its own pier. Each pier was about 450 feet long and one-third as wide. Railroad spur tracks ran into each shed, one of which collected freight intended for shipment to New York, and the other was dedicated to Boston goods. A third shed connected the two piers along the riverfront and provided office and passenger space. As many as six ships at once could dock in the new complex. (Courtesy Bob Basford.)

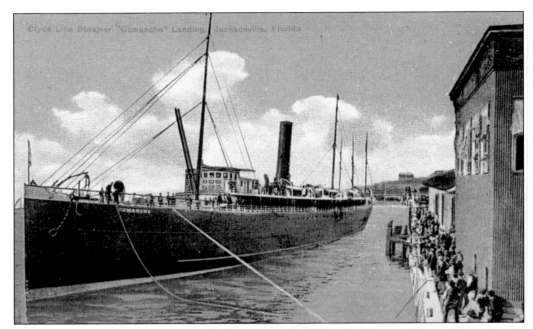

Comanche weighed 3,500 tons and was built in 1896. She had quadruple expansion engines and made the run between New York and Jacksonville in less than 53 hours. Comanche also had all the modern improvements, including the following: electric lights and bells in saloons and staterooms, bath and smoking rooms, a social hall, and a grand dining saloon. She accommodated 335 passengers.

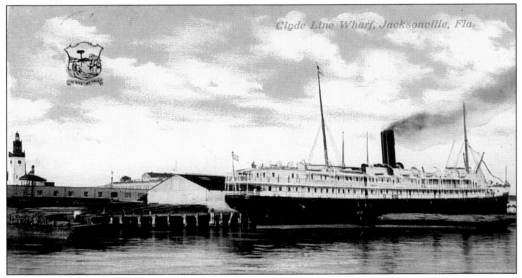

A Clyde Line brochure states, "Clyde Line is the only line which runs steamers from New York all the way through to Jacksonville, Florida . . . A run of about 12 hours from Charleston completes the voyage to Florida, where the St. Johns River is usually entered soon after daylight, and Jacksonville is reached in a few hours, bringing to a pleasing conclusion, in the midst of novel surroundings and at the most convenient center for reaching all parts of Florida, what is perhaps the pleasantest ocean voyage accessible to the American traveler."

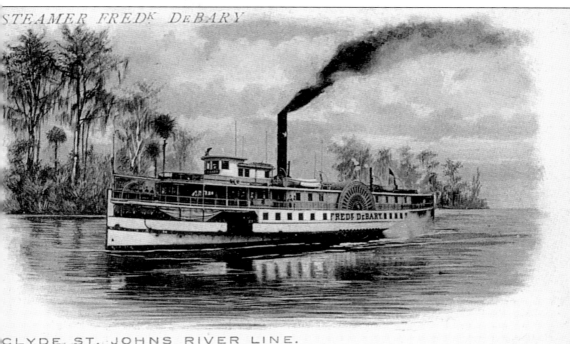

STEAMER FREDK DeBARY

CLYDE ST. JOHNS RIVER LINE.

PASSENGER OFFICE:

122 WEST BAY ST., JACKSONVILLE, FLA.

The *Frederick DeBary* was originally owned by the DeBary Line, which was later acquired by the Clyde Line. She was in port soon after the Great Jacksonville Fire. Along with other Clyde Line ships, her personnel assisted the fire's victims. Some craft even steamed away from the wharf, traveling up river to give citizens an opportunity to breathe fresh air. The Clyde St. Johns River Line offered passage among Jacksonville, Palatka, Sanford, Enterprise, and intermediate landings. The fare between Jacksonville and Sanford was $3.75, including meals and berth.

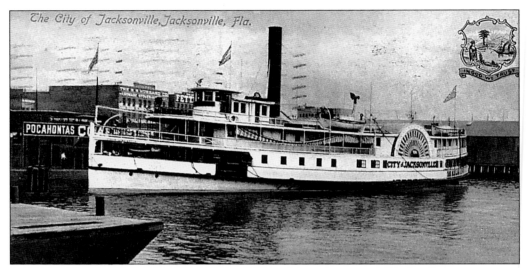

The *City of Jacksonville* is depicted at her mooring in this 1911 postcard. She was an iron-hull side-wheel steamer, built in 1882 by Harlan & Hollingsworth at Wilmington, Delaware. She was wrecked at Portsmouth, North Carolina, in September 1889. She was later raised and served on the St. Johns River for many years. She was converted to a dance hall, *c.* 1933.

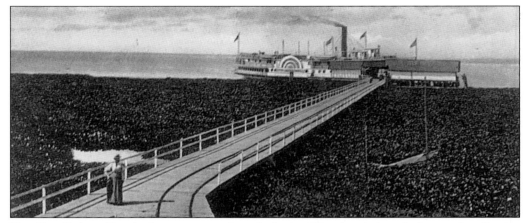

The *City of Jacksonville* unloads passengers at the end of a pier. Water hyacinths, a freshwater, free-floating plant, clog the area between the shore and the channel. Not indigenous to the area, water hyacinths began to appear in the St. Johns River in the late 1880s or early 1890s. The water hyacinth is nothing if not prolific—the plants double their area of coverage every month during the growing season. Beginning in the 1890s, water hyacinths spread to the point of impeding St. Johns River navigation. A variety of (unsuccessful) efforts were undertaken to control this beautiful but "pesky" plant. In 1901, the United States Corps of Engineers sprayed nearly 250,000 gallons of arsenic acid on the waters of Black Creek, Rice Creek, Deep Creek, Blue Springs, and the St. Johns River. It is not noted if the hyacinths were affected, but cattle were killed and the practice of spraying was abandoned for a time. From 1906 to 1939, the most effective destroyer of the plant was the "saw boat." This boat featured circular saws protruding from the front and "outriggers" containing additional saws at each side of the stern. The saws not only cut the hyacinths in 10-foot strips, but also provided propulsion for the boat. In its heyday, the water hyacinth plant effectively immobilized many St. Johns River pleasure craft and smaller commercial boats. (Courtesy Bob Basford.)

Two

CITY SCENES

Scenes of everyday life intrigued correspondents and card collectors 100 years ago as much as they interest modern observers. Early 20th-century Jacksonville moved by foot, boat, rail, horse, ox, and "horseless carriage." The views in this chapter offer us a glimpse of people with places to go and things to do.

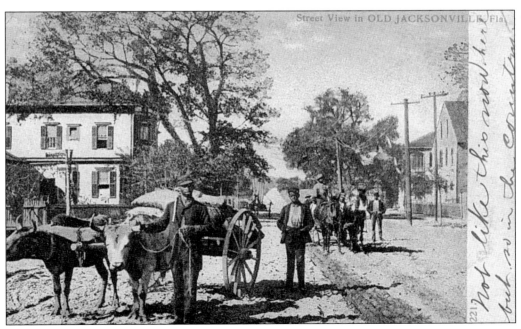

"Not like this now but so in the country . . ."

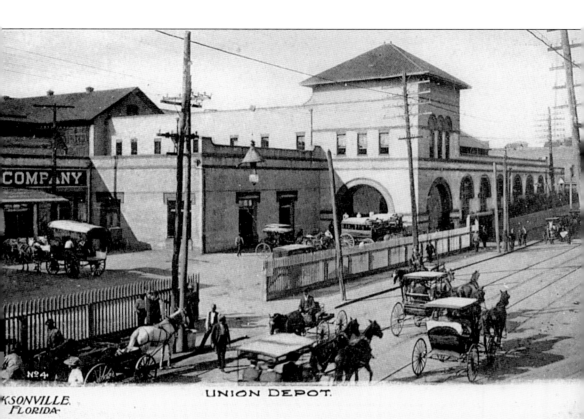

UNION DEPOT.

KSONVILLE.
FLORIDA.

Construction of Union Terminal began in 1890, and was motivated by Henry M. Flagler. Flagler's railroad eventually became the Florida East Coast Railway. Flagler's partner in the construction of the terminal, the Florida Central and Peninsular Railroad, eventually became CSX Corporation. When the main terminal of Union Depot was completed in 1897, a *Times Union* reporter wrote, "More than one gentleman, with the hayseed floating placidly from his uncombed locks, and his baggage checked for Waycross, found himself in the wrong pew; and the merciless hack-drivers of Jacksonville reap a rich harvest by conveying belated innocents to the proper place." In 1919, Union Terminal was replaced by the Jacksonville Terminal (now the Prime Osborn Convention Center).

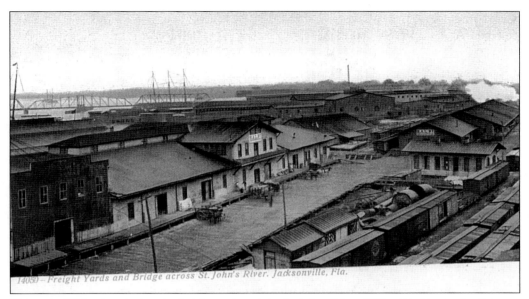

14050 – Freight Yards and Bridge across St. John's River. Jacksonville, Fla.

This early 1900s view depicts the freight yards and the St. Johns River 1890 rail bridge in the distance. Horses, trains, and a schooner are all at work or awaiting cargo in this postcard.

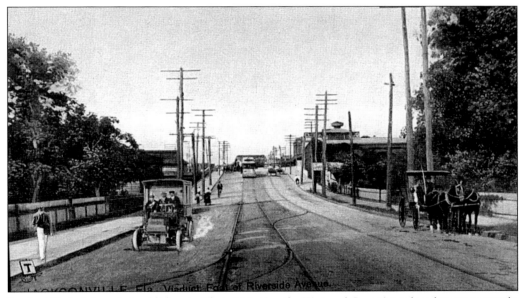

Raphael Tuck & Sons (art publishers to Their Majesties, the King and Queen) produced many postcards. The reverse-side caption on this one reads, "Viaduct, foot of Riverside Avenue. One of the finest viaducts in the South is in Jacksonville, connecting Riverside suburb with the city proper; built of concrete and steel, it is 1,110 ft. long and it is crossed by a double streetcar line with separate ways for the travel of teams and pedestrians."

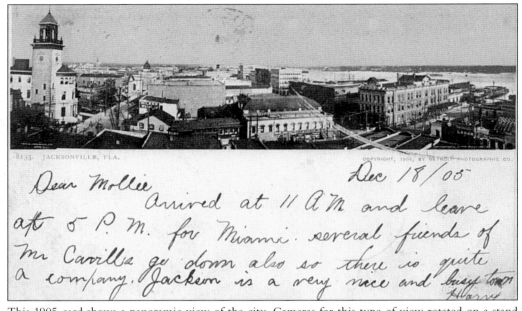

This 1905 card shows a panoramic view of the city. Cameras for this type of view rotated on a stand in synchronization with film movement inside the camera, thus enabling a "wide-angle" image. This postcard was published by Detroit Publishing Company. The post office and government building (at left of view) was located at the northeast corner of Forsyth and Hogan Streets. The St. Johns River is in the background.

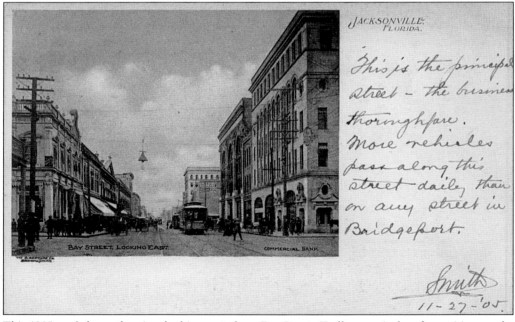

This 1905 card shows the view looking east along Bay Street. Trolley cars jockey for position on the crowded avenue with horses and pedestrians alike.

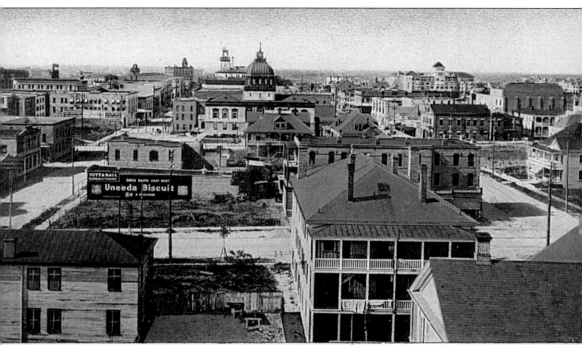

The writer dates this bird's-eye view of Jacksonville as 1912. A domed city hall is visible in the upper center, with the post office/federal building behind it to the left. Toward the right upper portion of the view is the Windsor Hotel (with the tile-roofed tower). Note the "Uneeda Biscuit" billboard.

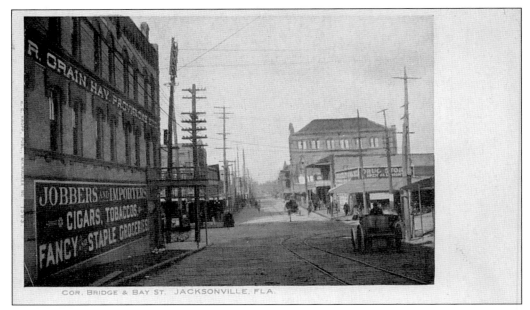

This view shows the "corner of Bridge and Bay Street." Bridge Street is now Broad Street. E.C. Kropp, a prominent Milwaukee postcard publisher, published this card. The drug store on the right is "open all night."

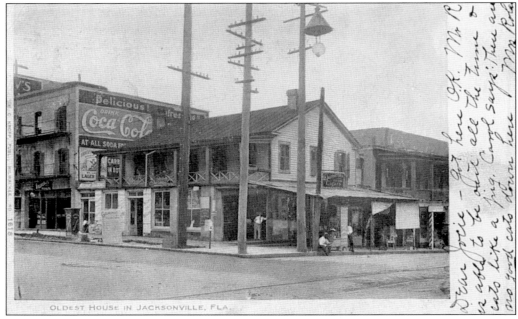

In another E.C. Kropp view, Jacksonville's "oldest house" is depicted in this 1906-era card. The oldest house was torn down for the construction of an office building. While that office building was under construction in 1909, it caught the attention of a hotelier who bought the building and started over. He employed architect Henry Klutho to construct what would become the Seminole Hotel. The Seminole Hotel opened on New Year's Eve in 1909 and, at ten stories, was a Jacksonville giant.

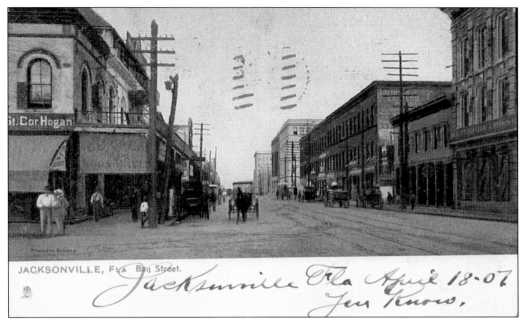

This "Tuck" postcard, mailed in 1907, contains the following reverse-side caption: "Bay Street is the chief business thoroughfare and upon it are the more important stores and shops. It extends for a mile quite near, and parallel to, the St. Johns River. The Union Railway Station is at the upper end, and electric cars connect it with the principal streets and hotels."

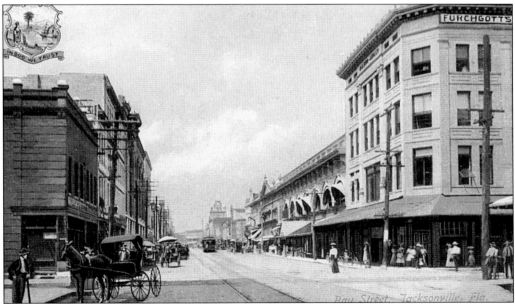

This card showing a Bay Street view is postmarked 1908. Part of the "Florida Artistic Series," this postcard was printed in Germany. On the reverse side of the card, "Leonard" writes, "This is Papa's store." Leonard was apparently referring to Furchgott's, a long-time Jacksonville department store that may be seen in the right portion of the view.

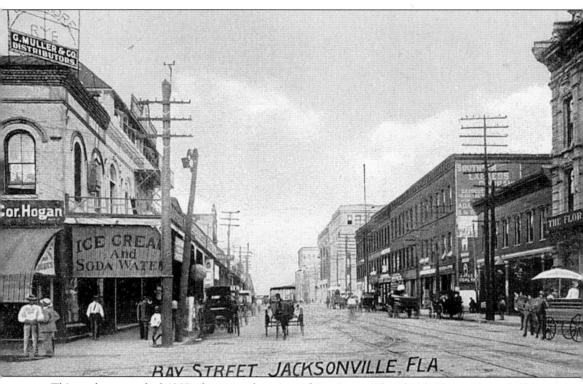

BAY STREET JACKSONVILLE, FLA.

This card, postmarked 1908, shows another view of Bay Street. The Florida Times-Union building is at the extreme right. The newspaper dates back to the *Florida Union*, a four-page, six-column weekly war newssheet first published in Jacksonville in 1864. The newspaper first became a morning daily about 1879. Known for a time as the *Florida Union*, it later became the *Florida Times-Union and Citizen*, adopting its present name in 1903.

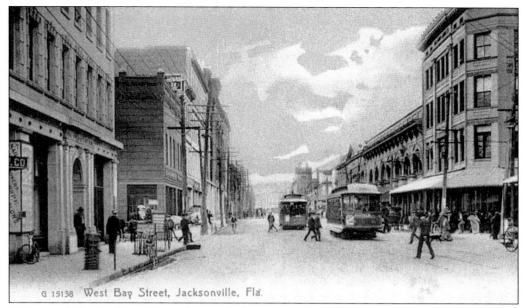

This view of West Bay Street features (at far left) the Dyal–Upchurch Building. Note the "plows" advertised for sale on that building's extreme left-hand column. Designed by Henry J. Klutho immediately after the 1901 fire, the Dyal–Upchurch Building was the first major post-fire structure downtown. It served as the home of its namesake lumber and investment firm. The Atlantic National Bank also had its offices in that building for many years. The right-hand streetcar is bound for the Fairfield area.

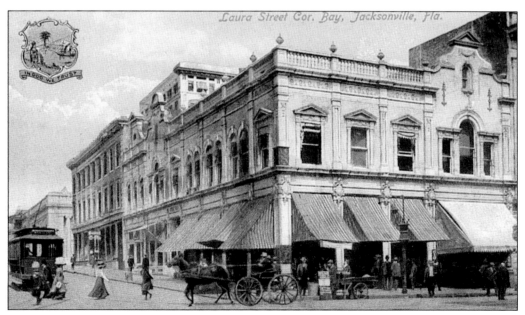

This "Florida Artistic Series" postcard was published by the H. & W. B. Drew Company and printed in Germany. This card depicts the "Old Bisbee Building," which was constructed four months after the Great Fire.

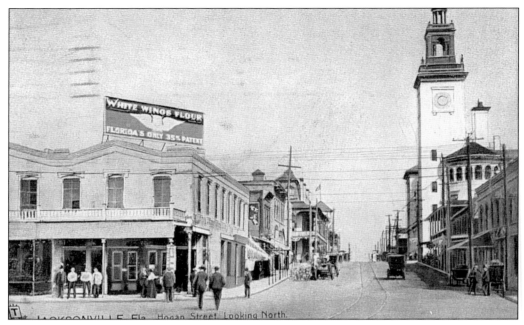

This "Raphael Tuck" postcard looks north on Hogan Street. It features the government and post office building (to the right), as well as a "White Wings Flour" billboard. The Windsor Hotel is seen on the left side of the street in the distance (turret with flag on top).

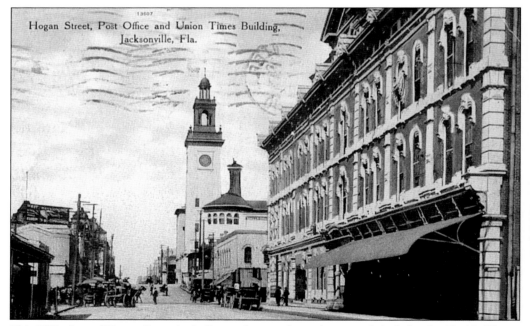

This 1910 view of Hogan Street is similar to the one above; however, it includes the Florida Times-Union building. Hogan Street appears to rise to a hill in both postcards on this page. A White Wings Flour billboard can be spotted on the left, although the design has changed from that of the above card.

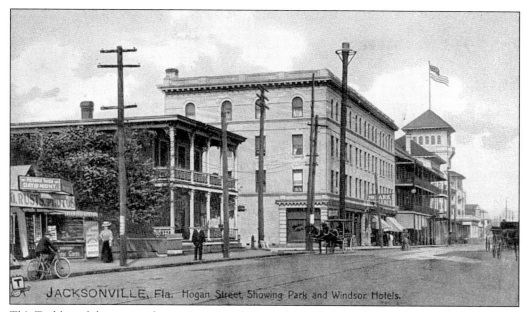

This Tuck's card shows a northwest view toward Hogan Street. It shows the Windsor Hotel (flag) and the Park Hotel. At the lower left of the image is the photography store of O. Rust. Mr. Rust's photographs appear in many of the postcards in this volume and are indicated (usually in a corner) as "Photo by Rust." (Courtesy Bob Basford.)

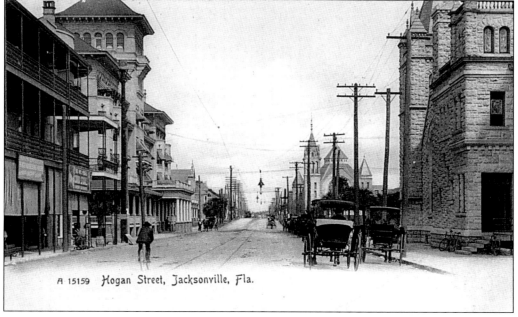

Bicycles and horse-drawn carriages traverse Hogan Street in this 1908-era card, and the Park and Windsor Hotels appear at left. (Courtesy Bob Basford.)

This 1907 card depicts a different view of Hogan Street. The Seminole Club is located at the right. Immediately behind it is the northern elevation of the Windsor Hotel. The post office/government building appears in the background, on the left side of Hogan Street.

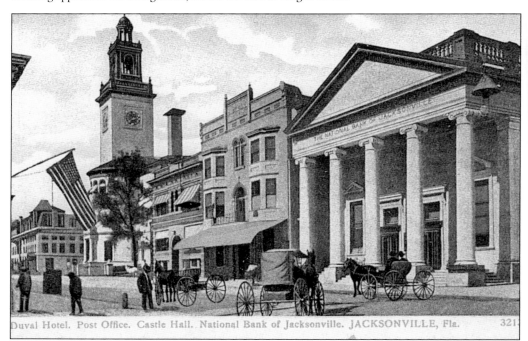

Duval Hotel. Post Office. Castle Hall. National Bank of Jacksonville. JACKSONVILLE, Fla. 321

This view of Forsyth Street features the National Bank of Jacksonville. The bank was founded in 1877 by William B. Barnett and his son as the Barnett Bank, and it soon became the largest bank in Florida. Barnett changed its name in 1888 to National Bank of Jacksonville; and in 1908 the name changed again to Barnett National Bank. Over the years, at least two of Barnett's bank buildings enjoyed the title of "tallest in Florida." The Barnett Bank eventually merged into a company now known as the Bank of America.

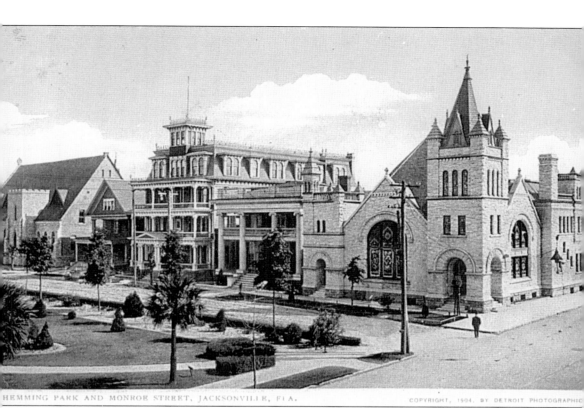

HEMMING PARK AND MONROE STREET, JACKSONVILLE, FLA. COPYRIGHT, 1904, BY DETROIT PHOTOGRAPHIC

This 1906 card was published by the Detroit Publishing Company. The Snyder Memorial Methodist Church is on the left and the First Christian Church (now demolished) is on the right.

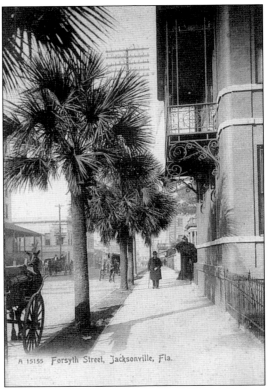

Palm tree–lined Forsyth Street stretches pleasantly into the distance in this pre-1907 postcard. The bowler- and overcoat-bedecked gentleman making his way toward the camera reminds us of the cold weather that steals into Jacksonville on occasion.

A 15155 Forsyth Street, Jacksonville, Fla.

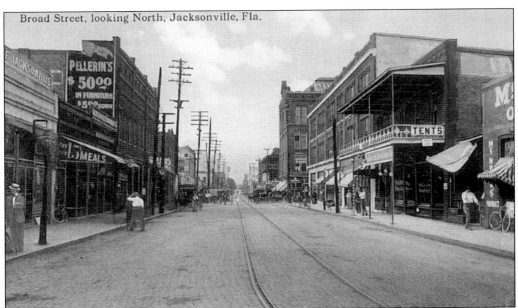

Broad Street, looking North, Jacksonville, Fla.

Gazing north on brick-paved Broad Street, it is difficult to decide whether to take in a 15-cent meal (on the left) or to purchase a tent from the store at right. The Pellerin's Furniture sign (left) portends Broad Street's longtime status as a center of furniture stores.

Three

GOVERNMENT AND COMMERCIAL BUILDINGS

The post-fire building boom included both public and private sectors. Unlike today's box-like government structures, Jacksonville's municipal buildings of the early 1900s were just as architecturally interesting as their private counterparts. Pre-World War I postcards provide a seemingly endless variety of views. Virtually every significant structure in Jacksonville is among them.

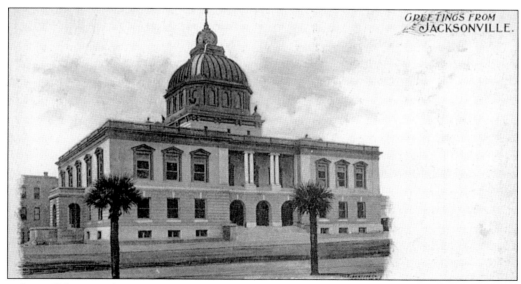

Jacksonville's original "City Hall and Market" was built in 1896 on Adams Street at Ocean Street and was completely destroyed by the Great Fire. The pictured Jacksonville City Hall, designed by architect Henry Klutho, was built on the same site and opened in March 1903. A New York artist was engaged to paint the interior of the city hall dome at a cost of $12,000. By the 1920s, this city hall was already inadequate and the building was demolished in 1960.

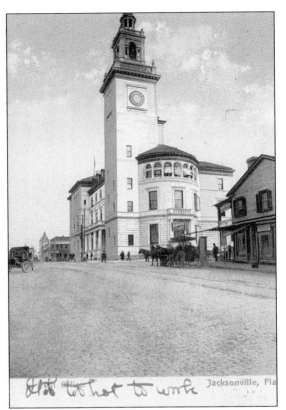

Completed in 1895, with walls of Tennessee marble, this building served as Jacksonville's post office and home of the United States District Court and other federal offices. Jacksonville's postal service was officially established in 1824, with mail delivery by horseback, stagecoach, rail, and steamer. This building, on the northeast corner of Hogan and Forsyth Streets, survived the Great Fire but not the wrecking ball.

The State Courthouse (below, left), located on Market Street between Forsyth and Adams, was constructed within a year after the Great Fire destroyed the old one. Across the street, the Armory (below, right) was the site of the two earlier courthouses. The Armory building shown was constructed from the walls of the burned-out courthouse. This photograph is by O. Rust (see page 31). Mr. Rust seems to have signed the image twice, but either he or the publisher attempted to erase his name in the lower right corner.

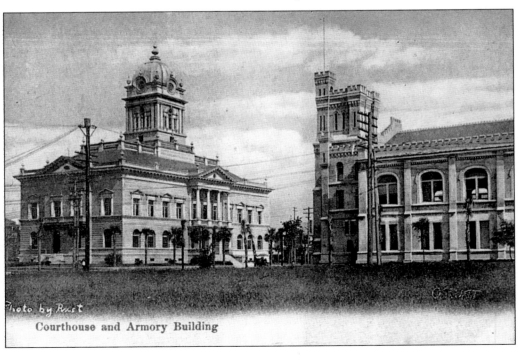

Courthouse and Armory Building

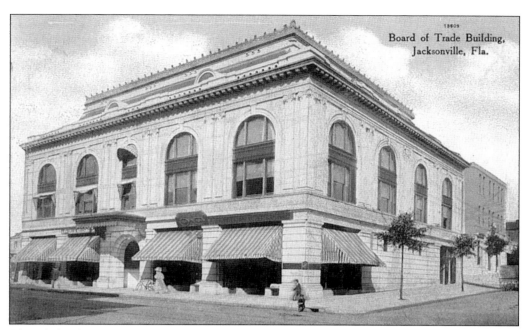

Board of Trade Building, Jacksonville, Fla.

A board of trade existed to attract business and industry to Jacksonville as early as 1856; but the organization disbanded during the War between the States. In January of 1884, 20 businessmen, organized by J.Q. Burbridge, formed a permanent board of trade in Jacksonville. After the Fire, the board of trade erected the building pictured here and it was occupied May 18, 1904. In 1915, the board of trade became known as the "Chamber of Commerce."

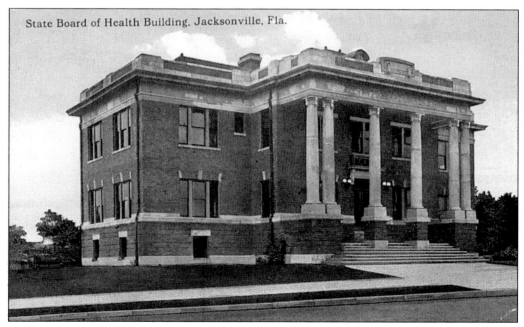

State Board of Health Building, Jacksonville, Fla.

The State Board of Health Building was constructed in 1911. The City Jail was once located on this same site, in the 1200 block of Julia Street.

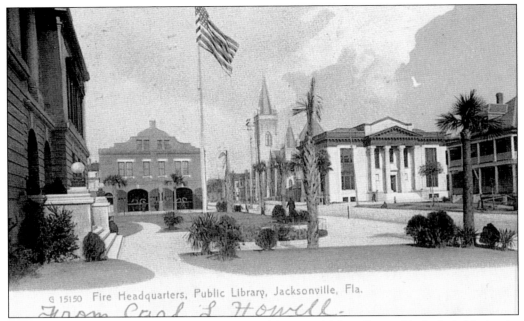

This postcard offers a 1907 view of the intersection of Ocean and Adams Streets. To the far left is the city hall. To the left of the flagpole is the Central Fire Station and the columned building is the Jacksonville Free Public Library. First Presbyterian Church is in the center background.

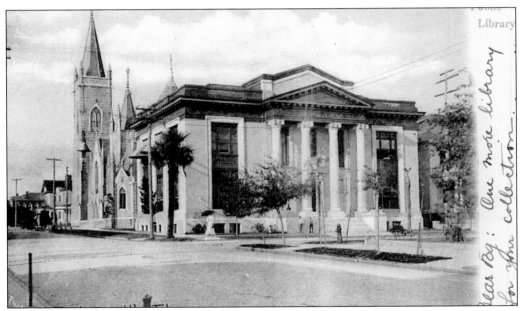

This incarnation of Jacksonville's Free Public Library was constructed in 1903, courtesy of a donation by steel magnate and philanthropist Andrew Carnegie. The architect was Henry J. Klutho. The building was abandoned but then restored and is now occupied by one of Jacksonville's oldest law firms, Bedell, Dittmar, DeVault, Pillans & Coxe. The Jacksonville library system dates from 1877; and this building replaced one that had been destroyed by the Great Fire. This photo is by O. Rust.

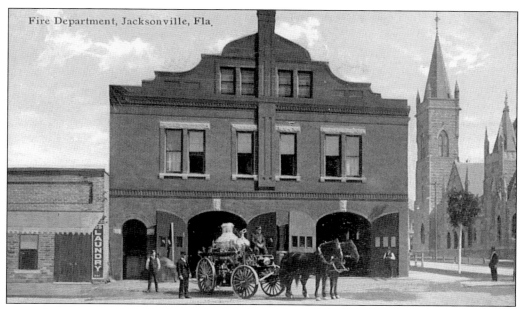

Fire Department, Jacksonville, Fla.

The Central Fire Station was constructed in 1901, and continued as a fire station for many years. In the early 1850s, Jacksonville acquired a fire-fighting device in the form of a water pump worked by handles on either side; but the pump was itself burned in a large 1854 fire. After years of volunteer efforts, a paid fire department was established in 1886. The first call to the new department was a false alarm.

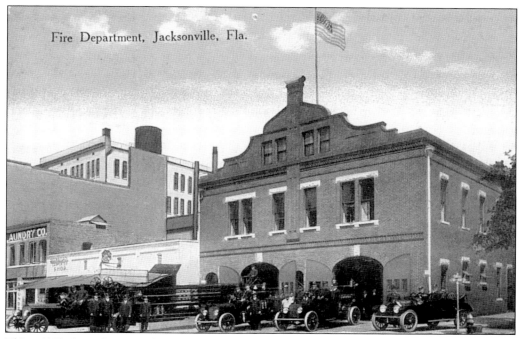

Fire Department, Jacksonville, Fla.

This *c.* 1910 photo shows another view of Central Fire Station.

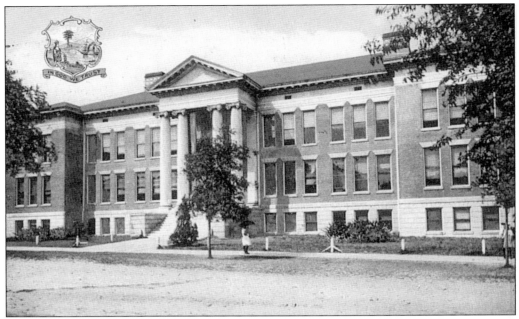

"Bess" wrote this card's message in a most artistic hand. She states, "I am grinding away in this big school." The "big school" was located at 345 East Church Street and was known as Central Grammar School. It was constructed in 1902, but is now demolished.

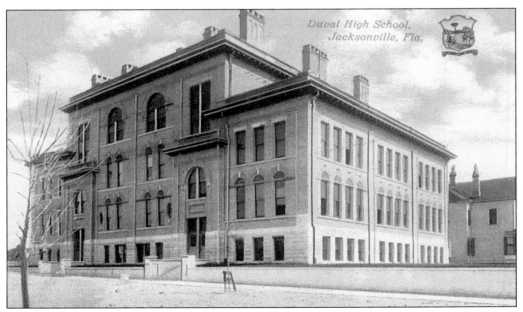

Duval High School had its first graduates (three boys) in 1877. The original building that housed Duval High School was destroyed by the Great Fire of 1901. For a time, classes were held at various locations, including Central Grammar School (above). The building shown here was completed in 1908. Located at 605 North Ocean Street, the school building has been converted into residential apartments. Duval High School closed in 1927, after serving as the city's only high school for nearly 50 years.

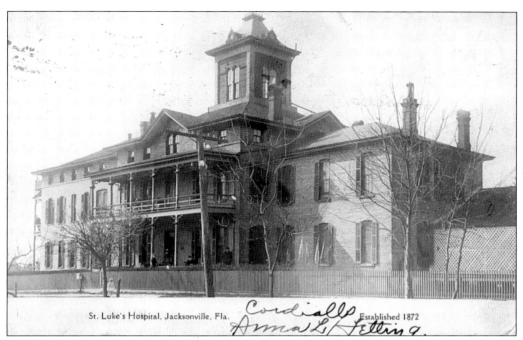

St. Luke's Hospital, Jacksonville, Fla. *Cordially Anna L. Petting.* Established 1872

St. Luke's Hospital was established in 1872 and survived the Jacksonville Fire This 1906 postcard shows Old St. Luke's Hospital as it appeared after the 1887 addition of a south wing. The building still exists today; however, both wings shown in this card have been removed. St. Luke's moved its operation from this location on January 26, 1914, to a new hospital in Springfield. The hospital recently relocated to new quarters on J. Turner Butler Boulevard in the Southpoint area.

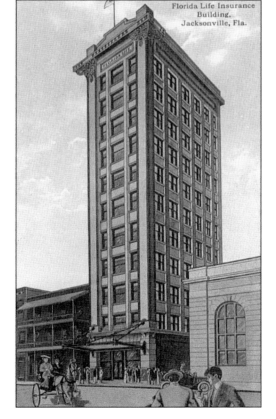

Florida Life Insurance Building, Jacksonville, Fla.

The Florida Life Insurance Building was designed by Henry J. Klutho and completed in 1912. At 11 stories high, it was, for a short time, the tallest building in Jacksonville.

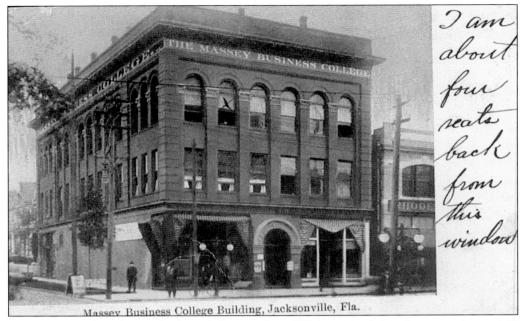

Massey Business College Building, Jacksonville, Fla.

I am about four seats back from this window

Written in 1914 by a Massey Business College student, "X" (second window from second story left) marks the location of the window out of which the student may have gazed during lectures. Until the 1970s, Massey Business College provided business and clerical training. (Courtesy Bob Basford.)

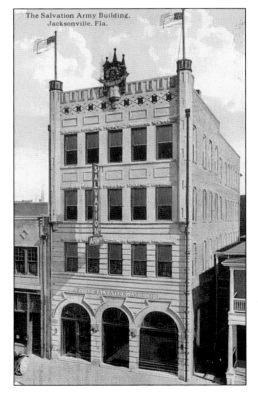

The Salvation Army Building. Jacksonville. Fla.

The Salvation Army Building was constructed in 1910 at 15 East Church Street. This building has since been demolished, but the army continues its service to the community. On January 11, 1891, the Salvation Army held its first street service in Jacksonville at the corner of Ocean and Bay Streets. The Salvation Army's slogan was, "A man may be down, but he is never out."

The "new" Bisbee Building is located on West Forsyth Street and was designed by noted architect Henry J. Klutho. The "old" Bisbee Building is shown on page 29. Ground was broken for the new building in June of 1908. The 10-story Bisbee Building was the pioneer skyscraper in Jacksonville. It was originally designed to be only 26 feet in width, but, just as it was being completed and almost ready for occupancy, the owners decided to tear down the east wall and double the building's width.

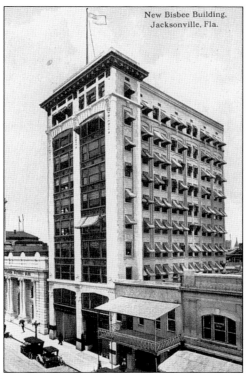

New Bisbee Building, Jacksonville, Fla.

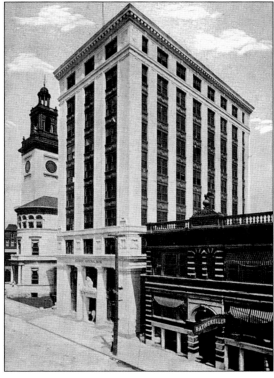

The Atlantic National Bank was organized in 1903 and Edward W. Lane served as its first president. The Lane family remained in control of the bank until it merged with First Union National Bank. This 10-story bank and office building, located at 121 West Forsyth Street, next to the post office/federal building (seen in the left background) was completed and occupied in October 1910.

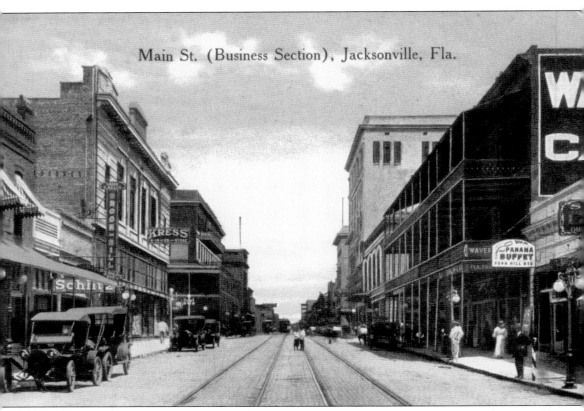

Main St. (Business Section), Jacksonville, Fla.

By the second decade of the 20th century, Jacksonville was a thriving retail center, as shown in this postcard of Main Street looking north from Forsyth Street. This card was printed by S.H. Kress & Co. to promote one of the largest dime stores in the country, at the southwest corner of Adams and Main. The building stands today, occupied by a law firm. (Courtesy John Welch.)

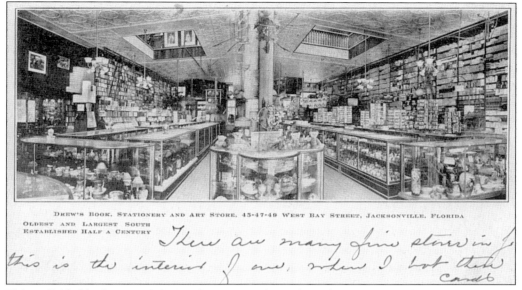

DREW'S BOOK, STATIONERY AND ART STORE, 45-47-49 WEST BAY STREET, JACKSONVILLE, FLORIDA
OLDEST AND LARGEST SOUTH
ESTABLISHED HALF A CENTURY

There are many fine stores in J this is the interior of one, where I bot the card

This undivided back postcard depicts the interior of Drew's Book, Stationery and Art Store. Founded in 1855, Drew Company still continues in business (as printers and stationers). Merchandise in this store was varied—from the skull, to the teddy bears, to the cuckoo clock. Dozens of postcards are arrayed in racks on the right-hand counter. The Drew Company published many of the cards featured in this volume.

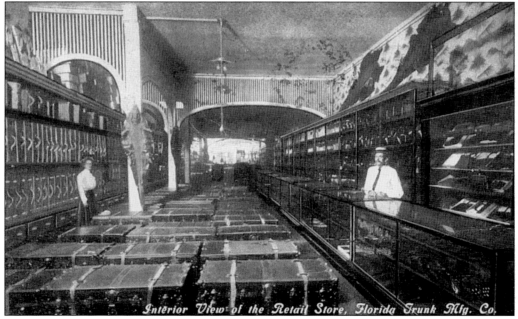

Interior View of the Retail Store, Florida Trunk Mfg. Co.

This 1910 advertising card was mailed to potential customers by Florida Trunk Company. On the reverse, the lettering touts, "Everything in fancy leather and alligator goods." Note the alligator skins on the column to the left and hanging on the right-hand wall near the ceiling. Women's handbags fill the cases to the right.

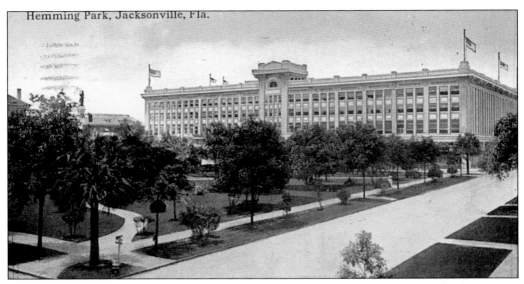

This card depicts the "new" St. James Building. The St. James Hotel occupied this site behind Hemming Park from 1869 until the Great Fire of 1901. Its fame was international. After the Fire of 1901, the property was purchased by the owners of the nearby Windsor Hotel to prevent competition. The Windsor's owners then sold the land to the Cohen brothers, who commissioned architect Henry J. Klutho to construct a store on the old site. Cohen Brothers's "Big Store" occupied the site for many years. The St. James Building was ultimately purchased by the City of Jacksonville. It was renovated and opened as the new Jacksonville City Hall on December 12, 1997.

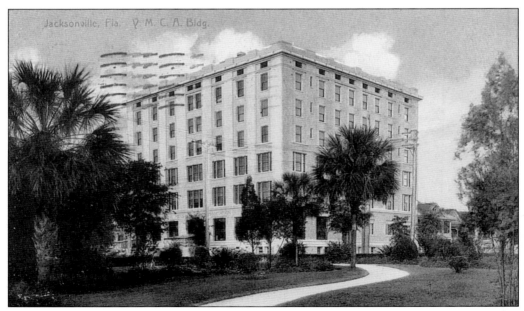

Jacksonville, Fla. Y. M. C. A. Bldg.

This January 1910 card features the Young Men's Christian Association (YMCA) Building. The writer astutely observes that it is "not as cold here as it is in Maine." The YMCA in Jacksonville dates from 1870; however, this Henry J. Klutho–designed building was constructed in 1909. Located at 407 North Laura Street, it has not been used by the "Y" since the 1920s. (Courtesy Bob Basford.)

Four

CLUBS AND ORDERS

*I*t has been said that Jacksonville is a "club town." That statement was probably no truer in the early 1900s than it *is now, but a number of clubs and orders did flourish here. The buildings in which their members gathered were often as distinct in personality as the groups they housed.*

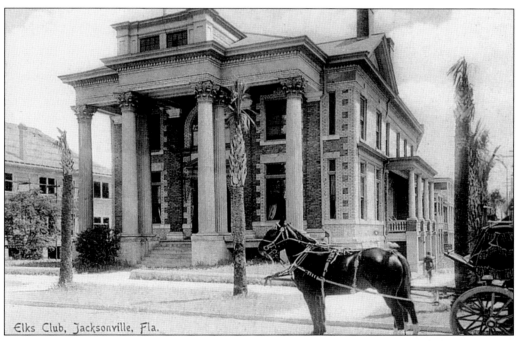

Elks Club, Jacksonville, Fla.

This postcard depicts the local lodge of the Benevolent and Protective Order of Elks. It was said that the order's initials (BPOE) also stood for "Best People on Earth." Nationally, the Elks were founded in 1868 as a charitable, fraternal, and patriotic association. The Jacksonville Lodge was the only Elks Lodge in Florida for some years. The local lodge's first clubrooms were located at the southwest corner of Bay and Market Streets.

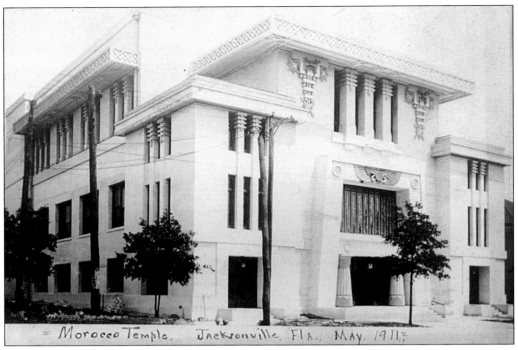

Morocco Temple, Jacksonville, Fla. May. 1911

The Morocco Temple is shown here in 1911, the year it opened. This edifice was the Jacksonville home of the Ancient Arabic Order of Nobles of the Mystic Shrine. It has been said that this fraternal order was founded at Mecca in the year of the Hejira 25. The building was designed by Henry Klutho and combines both the influence of "Prairie School" and that of the Shrine Order. Located at 219 North Newnan Street, the building exists today as an office building.

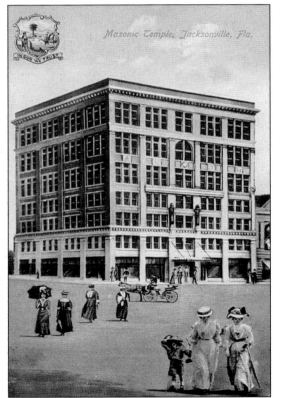

Masonic Temple, Jacksonville, Fla.

This "Florida Artistic Series" card is postmarked 1909 and depicts the Masonic Temple, located at 410 Broad Street. The building was completed in 1916, and was notable because it was constructed by African Americans for African Americans. The Masonic Fraternity is a worldwide association, probably descended from the fraternities and lodges of stonemasons and cathedral builders of the Middle Ages. In addition to the members of the Masonic Order, African-American businessmen and professionals occupied the building shown here.

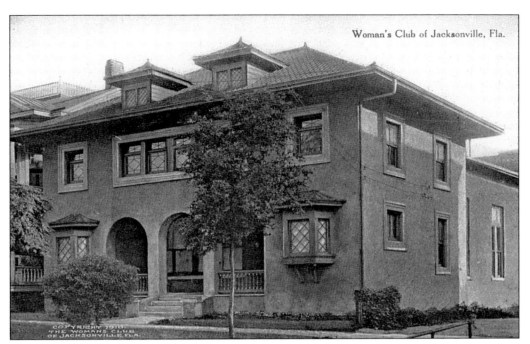

The Woman's Club of Jacksonville is shown in this 1910 view. Organized in 1897, the Woman's Club of Jacksonville was instrumental in matters of Jacksonville child welfare, public playgrounds, education, and culture. This building was constructed in 1903 at 16 East Duval Street. The Woman's Club moved to a location on Riverside Avenue in 1927; the pictured building was demolished in 1986.

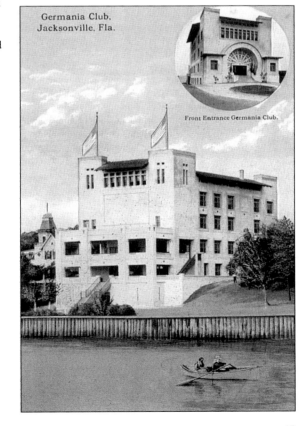

Germania Club, Jacksonville, Fla.

Front Entrance Germania Club.

Architect Henry J. Klutho, who was a member, designed the Germania Club. Prominent German-American residents frequented the club, which was located at 135 Riverside Avenue.

49

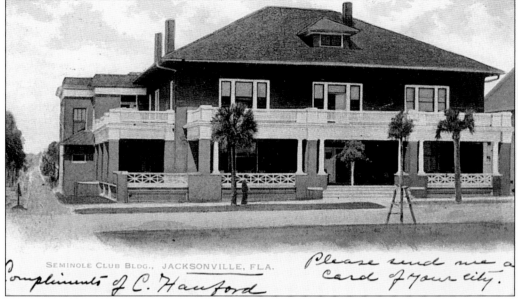

The Seminole Club was organized in 1887 as a men's social club. The first two buildings housing the club were burned. The view on this undivided back card shows the Seminole Club's third building, as it appeared upon its completion in 1902. Located at the northwest corner of Hogan and Duval Streets, the building faces the western elevation of the city hall at St. James. President Theodore Roosevelt delivered a speech from the porch of the Seminole Club during his 1905 visit to Jacksonville.

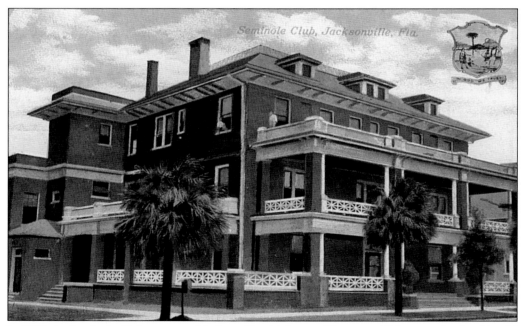

In 1907, the Seminole Club was remodeled to add a third story. The new addition contained residential rooms available to the club's bachelor residents. The Seminole Club is presently in a reorganization stage, and the building houses the club and a restaurant that is open to the public.

Five

HOTELS

During much of the American Civil War, Jacksonville was occupied by Union troops. The majority of Jacksonville's citizenry fled the occupation, and the city's economy deteriorated as a result. After the War between the States, Jacksonville tourism boomed for a time, but then visitors declined as the railroad pushed south and took travelers with it. Jacksonville's 1888 yellow fever epidemic did little to alter the tourist exodus. The Great Fire destroyed 10 hotels in 1901. Tourists or not, hotels played a great part in Jacksonville's cultural life. After the Fire, exciting new hotels took their places among the several that survived the conflagration. Postcards depicting those hotels were published in abundance.

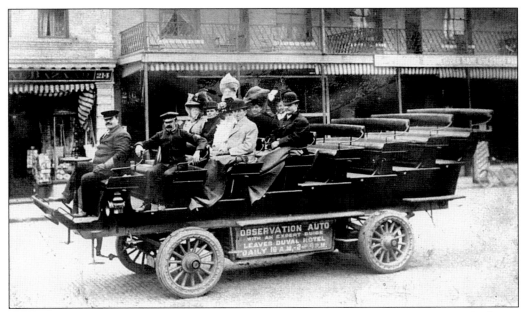

After the Great Fire destroyed ten of the city's finest hotels, only one, the Windsor, was rebuilt. Yet Jacksonville re-established sufficient hotels and tourism to warrant an "observation vehicle." The tour provided an "expert guide, leaving daily at 10 a.m., 2 p.m. and 4 p.m." from the Duval Hotel. J.A. Hollingsworth who billed himself a "tourist photographer" produced the postcard.

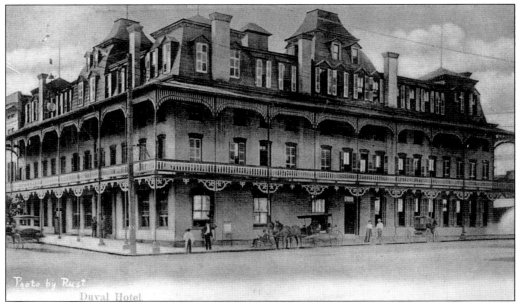

The Duval Hotel, one of the few city hotels to survive the 1901 Fire, opened in December 1893. After the Fire, the Duval's literature boasted that it was the "oldest hotel in Jacksonville, Florida," which was not entirely accurate. However, it was fair to say that the Duval occupied one of Jacksonville's most historic spots—a portion of the hotel was constructed on the 1816 homestead of L.Z. Hogans and his wife, Maria Taylor. (Photo by O. Rust; courtesy Bob Basford.)

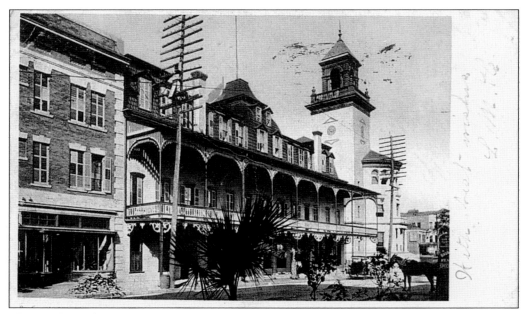

The Duval Hotel was located next door to the most recognizable building in Jacksonville, the post office. Such amenities as telephone, hot and cold running water, steam heat, and electric fans "in every room" were touted by the hotel. The postcard is copyrighted 1904.

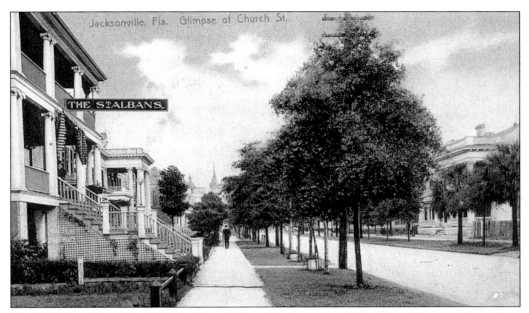

The St. Albans, located at 331 West Church Street (at the corner of Pearl Street), appeared as a large home. A walk east along the brick (and aptly named) Church Street led residents to an array of houses of worship. (Courtesy Bob Basford.)

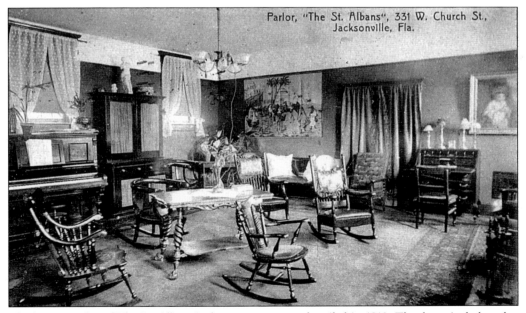

The homey parlor of The St. Albans is shown on a postcard mailed in 1910. The decor includes what appears to be electric lighting. At the time there were 6,082 local subscribers to electricity, and the city's population had climbed to 57,700.

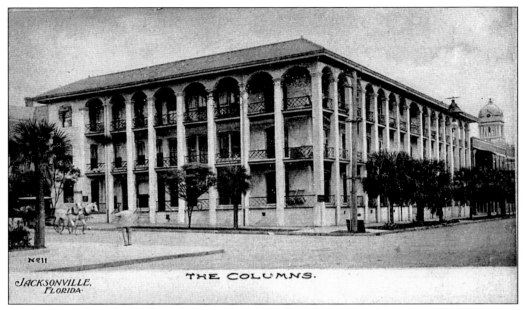

The Columns was located at 111 East Forsyth Street. Built after the Great Fire, the hotel incorporated architectural styles from some of the city's renowned pre-fire hotels, such as the St. James and the Windsor.

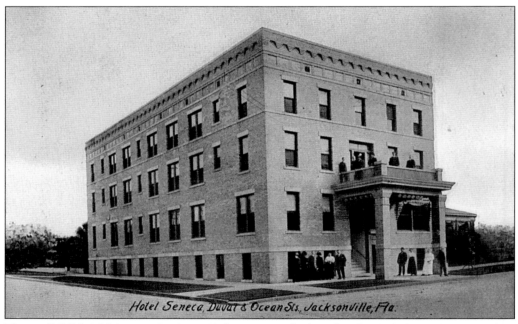

The small "all-brick" Seneca Hotel provided a promise of safety after the city's Great Fire. Located on the corner of Ocean and Duval Streets, it was only a few blocks east of Hemming Park (today's Hemming Plaza). The hotel advertised itself to be "just off the business district . . . quiet and homelike."

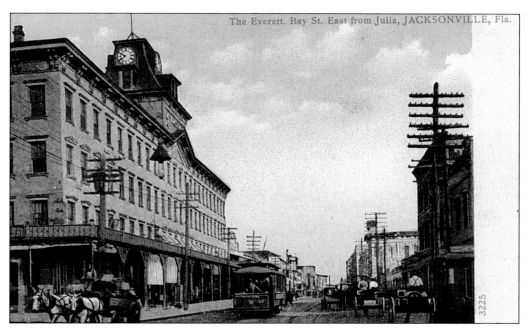

The Everett Hotel had its origins in 1873 as the 150-room Grand National Hotel. Located at Bay and Julia Streets, the hotel included a grand central clock and viewing tower. The hotel fronted a park with the river just beyond. In 1881, the Grand National was sold, renovated, and renamed the Everett. The property was later divided, and the newer Forsyth Street portion was sold and renamed the Aragon Hotel. The remainder of the structure retained the Everett name. When the Great Fire roared through the city the following year, the Aragon and the Everett were spared.

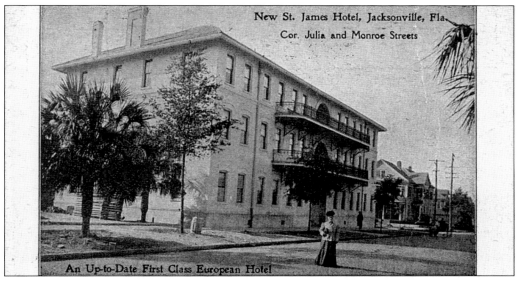

New St. James Hotel, Jacksonville, Fla.
Cor. Julia and Monroe Streets

An Up-to-Date First Class European Hotel

The New St. James Hotel, shown in this 1909 card, took its name from the most venerable hotel lost in the 1901 Fire, the 1868 St. James Hotel. The newer hotel shared few of the features of its namesake, comparing unfavorably in size, location, and architectural style. (Courtesy Bob Basford.)

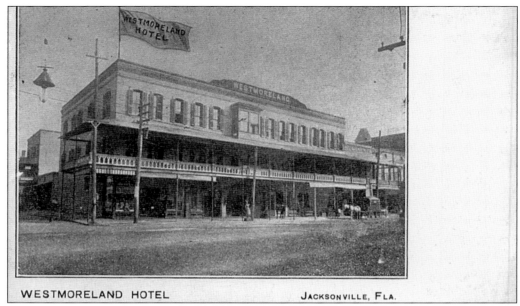

WESTMORELAND HOTEL JACKSONVILLE, FLA.

Located at 335 West Bay Street, the Westmoreland Hotel was on a major streetcar route, as were a number of the city's hotels. Prior to the 20th century, all of the city's streetcars were run by electric power. However, the original streetcar on the Bay Street route was mule powered—in the vernacular of the day, a "hay-burner." (Courtesy Bob Basford.)

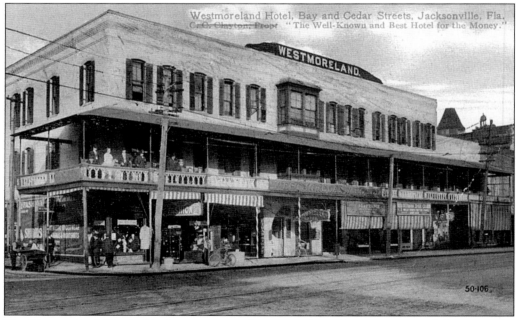

The Westmoreland Hotel offered guests a second-story porch to observe activities of the town. The street level portion of the hotel provided space for retail shops. The proprietor, Mr. C.C. Clayton, unabashedly advertised the establishment as "the well-known and best hotel for the money." (Courtesy Bob Basford.)

The Hotel Windle, 17 East Forsyth Street, was prominently located just west of the city's 1903 city hall. This postcard shows a portion of the city hall to the right of the hotel. Both the Henry Klutho–designed Jacksonville City Hall and the Hotel Windle were demolished in 1960 to make room for the Haydon Burns Library. Now, 41 years later, the Haydon Burns Library may soon meet the wrecking ball itself. (Courtesy Bob Basford.)

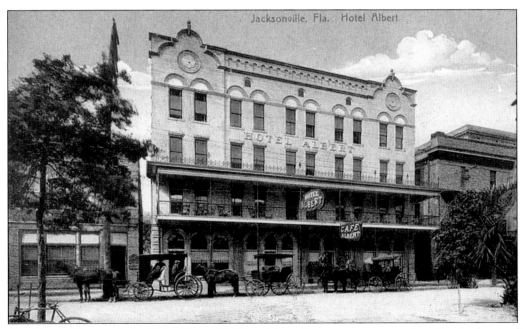

The Hotel Albert and the Cafe Albert, 19 West Adams Street, were marketed as "in the heart of Jacksonville, Florida." An additional floor was added to the building later. The remodeling appeared as if the identical top piece of the hotel was simply reset a story higher. Otherwise, the hotel, including the delightful overhanging porch, remained the same.

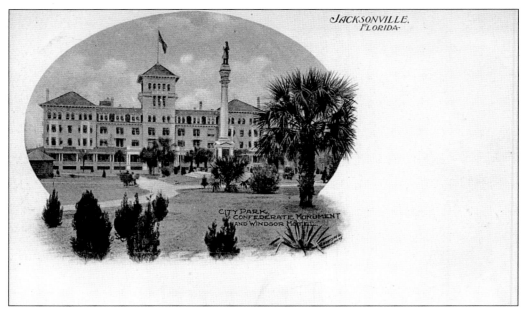

In 1898, resident Charles Hemming donated the Confederate statue, located in the center of "City Park;" and the park was renamed the following year in his honor. The Windsor Hotel was destroyed in the Great Fire and was the only major Jacksonville hotel rebuilt after the Fire. The "second" Windsor opened for business in February 1902 and was demolished during the early 1950s.

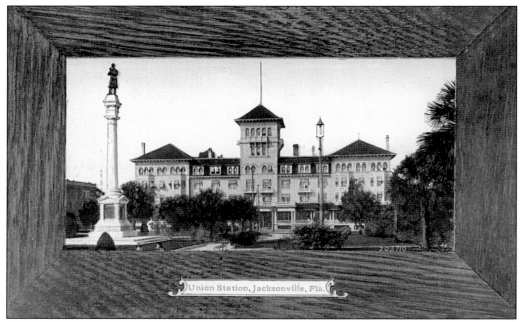

Valentine & Sons Publishing Co. of New York and Boston mis-labeled this "framed" view of Hemming Park (now Hemming Plaza) and the Windsor Hotel. Union Terminal is accurately depicted on page 22.

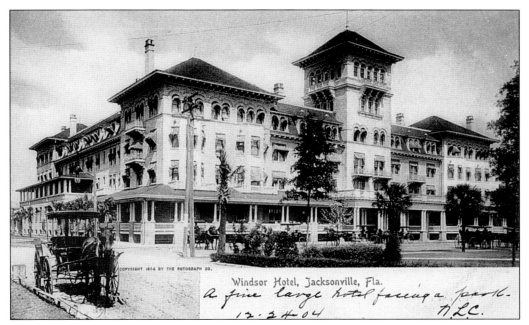

Windsor Hotel, Jacksonville, Fla.

A fine large hotel facing a park.
12-24-04 *N.L.C.*

The Windsor Hotel faces Hemming Park in this 1904 view. Once Cohen Brothers Department Store was constructed nearby in 1912, exhausted shoppers frequently joined hotel guests on the Windsor's expansive rocking chair verandas. The Windsor Hotel was a Jacksonville fixture until its demolition in the early 1950s.

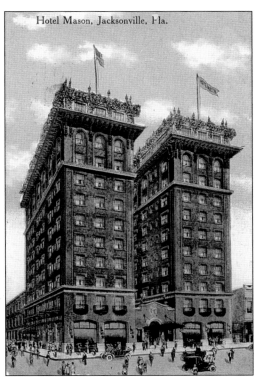

Hotel Mason, Jacksonville, Fla.

The Mason Hotel opened in December 1913. Visitors flocked to Jacksonville to enjoy the modern city by the river and to shop at the new Cohen Brothers, the largest department store in the southeast. The 11-story Mason Hotel occupied the corner of Bay and Julia Streets. Guests dined on the top floor and enjoyed an unhindered view of the St. Johns River. The building, with 250 guest rooms, was constructed for George H. Mason, at the cost of $1 million, including furnishings. Later, known as the Mayflower Hotel, this popular landmark was demolished in 1978.

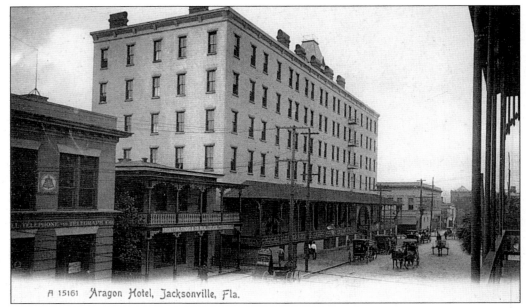

A 15161 Aragon Hotel, Jacksonville, Fla.

The Aragon Hotel, a Great Fire survivor, evolved from the 19th-century Everett Hotel, mentioned previously on page 55. Owner Nathaniel Webster decided to enlarge the Everett in 1885, and added six stories on the Forsyth Street side of the hotel. A mortgage on the construction lead to a foreclosure, and by court action building ownership was divided, with a sale of the six-story Forsyth side to Dr. Neal Mitchell in 1900. This portion became known as the Aragon. (Courtesy Bob Basford.)

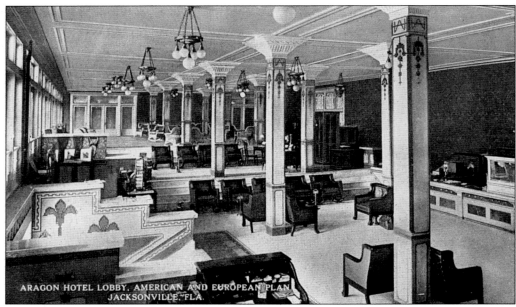

ARAGON HOTEL LOBBY, AMERICAN AND EUROPEAN PLAN
JACKSONVILLE, FLA.

A multi-level lobby welcomed guests to the Aragon Hotel where both the American and European plan were offered. Only a few steps away, a variety of Forsyth Street activities and shops were available. A five-block walk lead to the new Carnegie-funded library, designed by architect Henry Klutho. Hemming Park was two blocks north of the hotel, and the St. Johns River was only a short block and a half away.

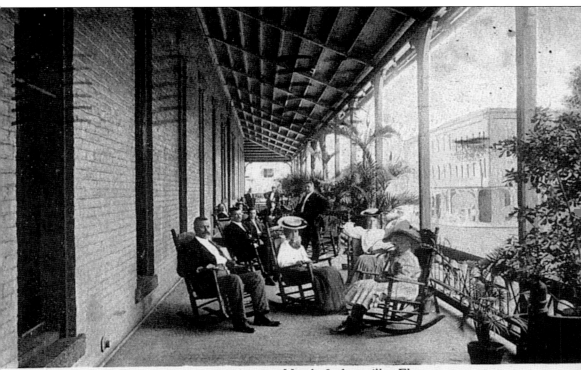

13597 Piaza of Arogon Hotel, Jacksonville, Fla.

This 1910 card shows the popularity of the Aragon Hotel piazza. Male hotel guests dressed in jackets, while the women routinely wore hats during the day. At the time, the silent filmmaking industry was emerging in Jacksonville, and the new industry brought an eclectic group of people to the city. The "movie-types" would challenge the community's acceptable standards of dress. (Courtesy Bob Basford.)

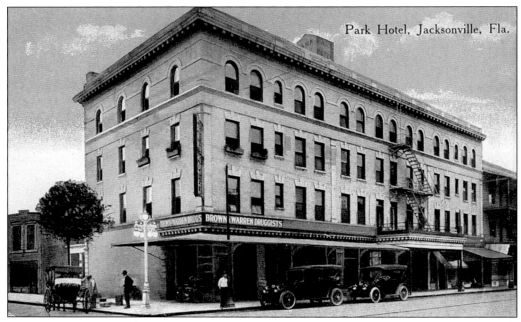

The Park Hotel, at 280 Hogan Street, marketed a contemporary image by placing the era's most modern automobiles next to the hotel for this photograph. Automobiles were the ultimate statement of all things modern. On March 6, 1916, Jacksonville held its first automobile show featuring 29 models, ranging from a $395 roadster to a seven-passenger Cadillac selling for $2,085. (Courtesy Bob Basford.)

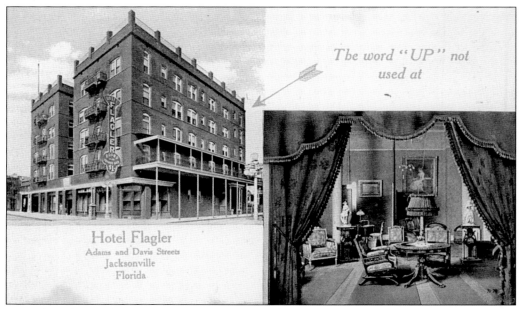

Located at Adams and Davis Streets, the Hotel Flagler was close to Union Station. From 1896 until 1919, Union Station was the arrival and departure point for travelers to the city. The hotel's name pays homage to Henry M. Flagler, railroad and hotel magnate, who undertook to create "American Riviera" south of Jacksonville. This 1914 card is penned in French. (Courtesy Bob Basford.)

The Seminole Hotel was located at the southeast corner of Forsyth and Hogan Streets. The Seminole was the pioneer skyscraper hotel of Jacksonville and the choice meeting place of its day. Noted as one of architect Henry Klutho's Prairie School masterpieces, this unique hotel was constructed of granite, stone, and brick. It was demolished nearly three decades ago. (See page 26.)

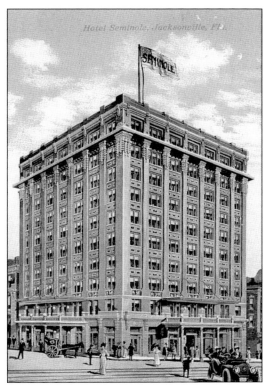

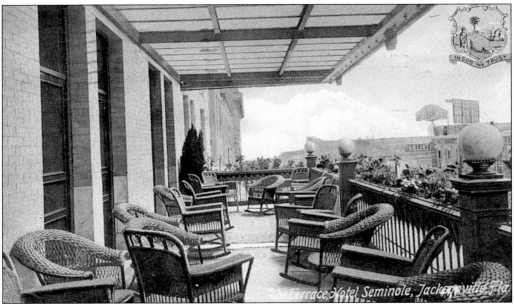

The second-story terraces of the popular Seminole Hotel were filled with brown wicker rockers. The ten-story exterior (shown above) included decorative Seminole Indian heads at the third-story level. A set of the heads is currently displayed at the Jacksonville Historical Center on the Southbank Riverwalk. (Courtesy Bob Basford.)

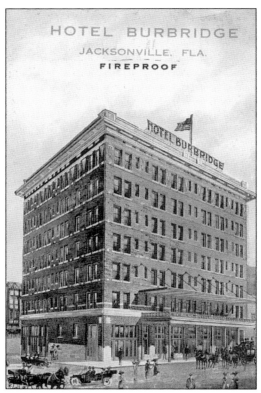

The seven-story Burbridge Hotel opened December 1911 and offered 175 guest rooms. The Burbridge Hotel lobby was a favorite of big game enthusiasts, displaying trophies of owner Ben Burbridge from his African and Alaskan adventures. The Burbridge, at 429 West Forsyth, was later renamed the Floridian and survived until 1981.

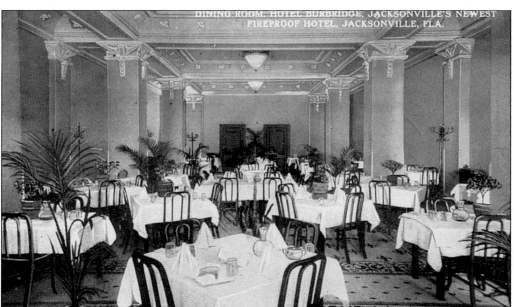

High-quality dining in elegant surroundings was a hallmark of Jacksonville hotels. The Burbridge Hotel's beautiful tile floor and linen service reminds one of a gentility that has disappeared from many modern establishments. (Courtesy Bob Basford.)

Six

HOUSES OF WORSHIP

A rich tapestry of religious faith has always permeated Jacksonville's city life. Spiritually, culturally, and architecturally, Jacksonville's houses of worship gathered and influenced their respective congregations. Most of the landmark buildings shown in this chapter are still standing today, although some have assumed new roles in the community.

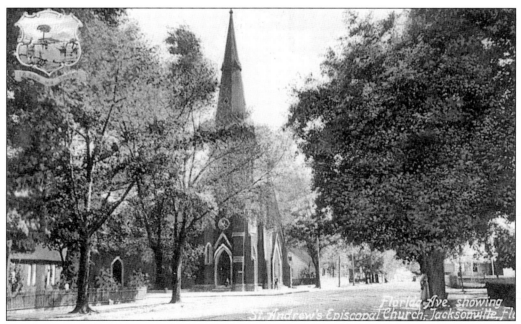

Old St. Andrews Church is located on A. Philip Randolph Boulevard (formerly Florida Avenue) directly west of Alltel Stadium (formerly the Gator Bowl). St. Andrews was built in 1887 and is the only major downtown church to survive the Great Fire. The City of Jacksonville and the Jacksonville Historical Society restored this abandoned Gothic Revival structure during the 1990s. It has been the home of the Jacksonville Historical Society since 1998.

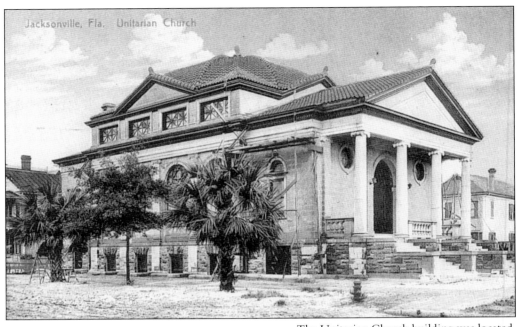

Jacksonville, Fla. Unitarian Church

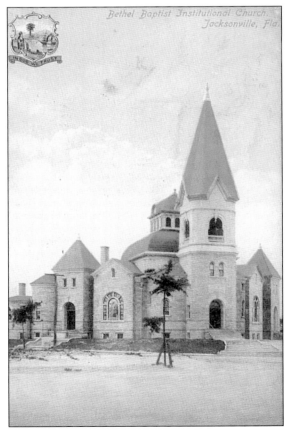

Bethel Baptist Institutional Church.
Jacksonville, Fla.

The Unitarian Church building was located at the southeast corner of Hogan and Union Streets. The first service was held in December of 1908; however, the building was not fully completed until 1909. The church auditorium had a seating capacity for 250 people. The architecture was Roman Ionic and the construction was concrete with copper trimmings.

The Bethel Baptist Institutional Church building, at 215 Bethel Baptist Street (formerly 1058 North Hogan Street), was built in 1904. The congregation was established in Jacksonville in 1838, and originally consisted of both black and white worshippers, but at the close of the Civil War, an effort was made to separate them. The blacks, who were in the majority, refused to give possession of the original church building to the white members. Eventually, the differences were resolved. The blacks' interest in the church was bought out; they constructed a new church building, retaining the Bethel Baptist name. The church building retained by the white congregation was then renamed "Tabernacle." That group ultimately became the First Baptist Church.

The First Baptist Church building, located at 133 West Church Street, was built in 1903, to replace the church's earlier building destroyed by the Great Fire. The 1903 church is 86 feet by 105 feet in ground area and is constructed of Bedford stone. Over the years, the First Baptist Church has added a number of buildings to its holdings, and it presently maintains a large and active presence in downtown Jacksonville.

The Methodists were the pioneers of organized church work in Jacksonville. A circuit rider traveled on horseback from St. Augustine. On Sunday, March 8, 1829, the circuit rider's diary entry read, "Preached at Jacksonville and dined with Mrs. Hart, and heard that some members of our church had been dancing." Despite such unpromising activity, a series of downtown Methodist churches were later built and outgrown by the local congregation. The Great Fire burned the then extant Methodist Church building and the building pictured below was constructed and opened in 1902. (Courtesy Bob Basford.)

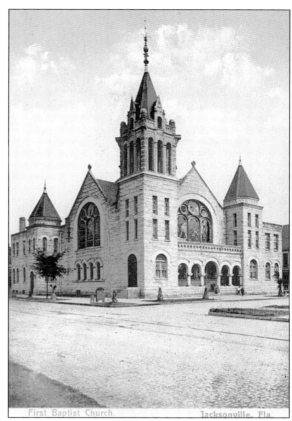

First Baptist Church. Jacksonville, Fla.

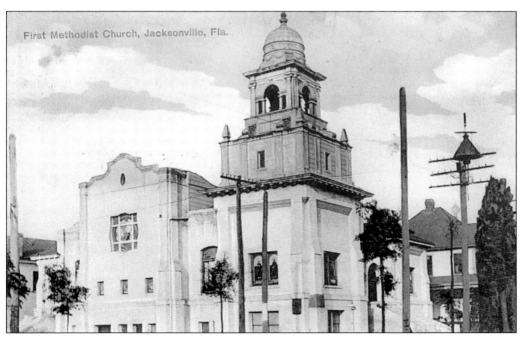

First Methodist Church, Jacksonville, Fla.

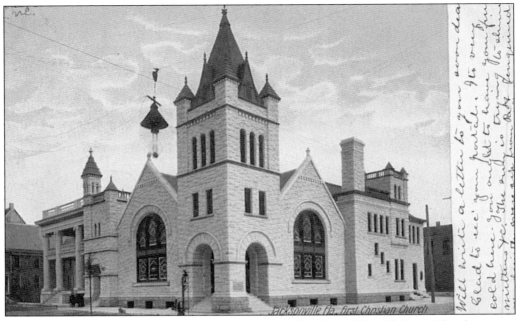

This view of First Christian Church was postmarked 1907. The church was located on the corner of Monroe and Hogan Streets, and it was architecturally similar to the contemporary building built by First Baptist Church (see page 67). The first services were held here in June of 1903. This church building was eventually demolished.

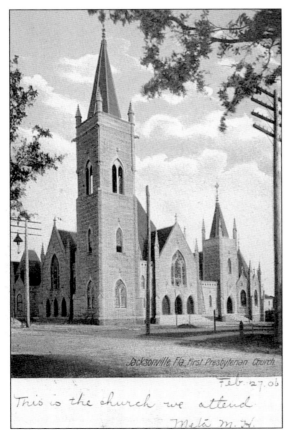

The First Presbyterian Church is located at 118 East Monroe Street. Construction of this building began immediately after the Great Fire and was completed in 1902. The plans for this church provided for an octagon-shaped auditorium with a seating capacity of 500, supplemented by two main galleries providing room for 50 more. The Sunday school room, with a capacity of 300 people, could be opened and used in connection with the auditorium. The First Presbyterian Church still actively continues its ministry from this same location. (See page 38.)

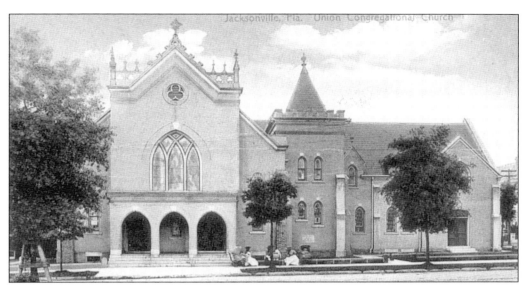

The Union Congregational Church of Jacksonville was organized in 1876 with 19 members. The Great Fire destroyed the church's Gothic-style building and another Gothic church was built in the same location—the southwest corner of Church and Hogan Streets. Because of street noises during service hours, that building was sold and a new church constructed on the south side of Church Street between Hogan and Julia Streets. The church was 102 feet by 80 feet overall, it was constructed of white brick and terra cotta, and it was occupied *c.* 1913.

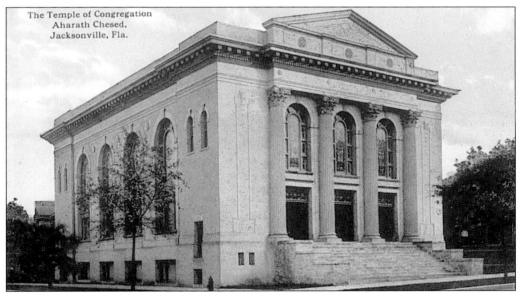

The Temple of Congregation Aharath Chesed, Jacksonville, Fla.

The Temple of Congregation Ahavath Chesed began its Jacksonville existence in 1882. Its building, located at the southeast corner of Laura and Union Streets, was destroyed by the Great Fire. The pictured building was started after the Fire and occupied on January 20, 1902. The congregation soon outgrew this synagogue, and it was sold to the Christian Scientists in January 1908. The Christian Scientists afterward sold it to the Greek Orthodox Church. Eventually, this building was purchased by First Baptist Church, which demolished it in 1980 for a parking lot. (Courtesy Bob Basford.)

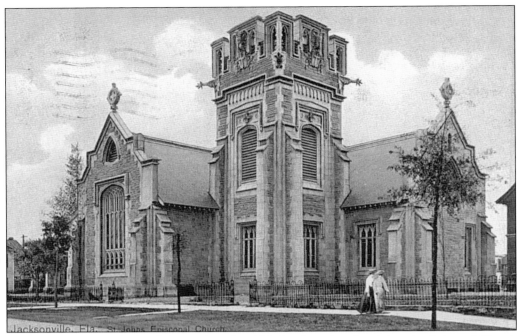

The St. Johns Episcopal Church (corner Duval and Market Streets) replaced the prior Episcopal Church building destroyed by the Great Fire. The first service in the new church was held on Easter Day, 1906. The church is built on top of "Billy Goat Hill," the highest point in the original city limits. The church was named a cathedral in 1951. Gargoyles, crosses, and eagles adorn the main tower.

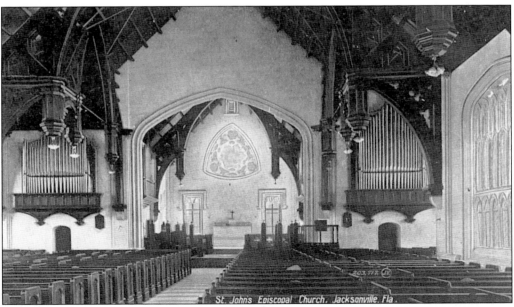

The interior view of St. Johns Episcopal Church shows the large organ pipes, located on both sides of the sanctuary. Unlike most cards of its day, which were printed in Germany, this card was printed in Great Britain.

The Roman Catholic Church established a parish in Jacksonville as early as 1847. In 1863, Union troops burned the church building and sacked it of everything of value. According to the *New York Tribune*, "The organ was in a moment torn to strips and almost every soldier who came out seemed to be celebrating the occasion by blowing through an organ pipe." After the war a new church building was constructed, but it was destroyed by the Great Fire. The cornerstone for the Church of the Immaculate Conception (pictured here) was laid by Bishop Kenny on April 7, 1907.

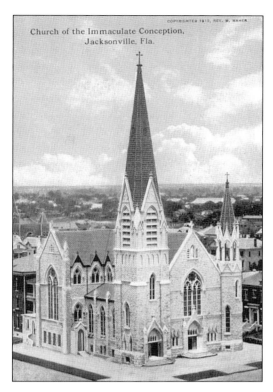

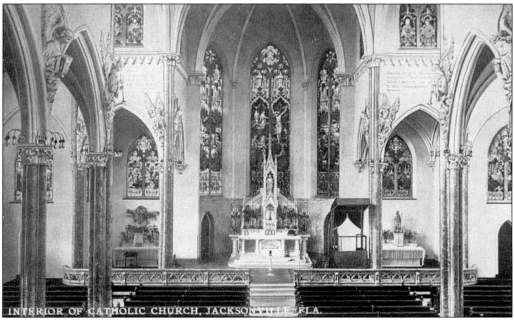

The interior of the Church of the Immaculate Conception is shown in this *c.* 1910 postcard. A cross that towers 178.5 feet above the sidewalk surmounts this Gothic church building. The superstructure of the church building is constructed of Kentucky limestone.

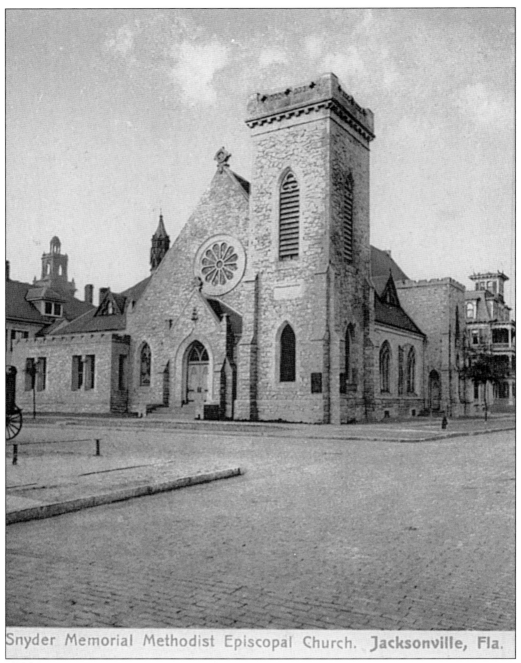

Snyder Memorial Methodist Episcopal Church. Jacksonville, Fla.

The Snyder Memorial Methodist Episcopal Church had its origins in the 1870s. The pictured building, at 226 North Laura Street, was completed in 1903, and replaced a church building destroyed by the 1901 Fire. Named in honor of a former pastor, the building is located across Hemming Park from the city hall at St. James. The building was de-sanctified when its congregation moved in 1992. The St. Johns River City Band (the "Official Band of the City of Jacksonville and the State of Florida") has purchased the building and intends to make it their headquarters.

Seven

PARKS

*A*s early as 1857, Jacksonville's "founder" Isaiah D. Hart planned a public square at what is now Hemming Plaza. Between the Fire and 1907, Waterworks Park, Dignan Park (now Confederate Park), and Springfield Park were connected to form a continuous park along Hogan's Creek to the St. Johns River. Riverside Park was deeded to the city in 1893. It once boasted five lakes, but that number is now reduced to one. Jacksonville's parks once sparkled with vitality and beauty. The grandeur depicted in this chapter's postcards is faded—for now.

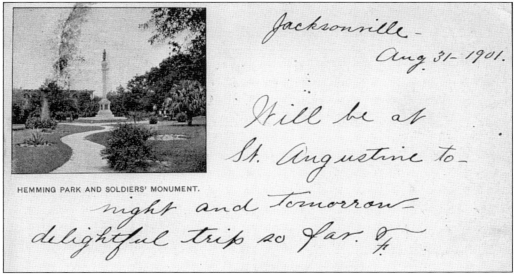

HEMMING PARK AND SOLDIERS' MONUMENT.

Prior to the Civil War, Jacksonville's founder Isaiah Hart set aside a square for use as a city park. The land was given to the city in a $10 exchange in 1866. The appearance of the park has changed over the years; so has the park's name, known respectively as City Park, St. James Park, Hemming Park, and Hemming Plaza. The one constant since 1898 is the Confederate Statue that represents a member of Jacksonville's Light Infantry. The statue became so hot during the 1901 Fire that the base glowed red. This postcard, mailed less than four months after the Fire, predates May 1901; the original Windsor Hotel seen in the background was destroyed by the Fire.

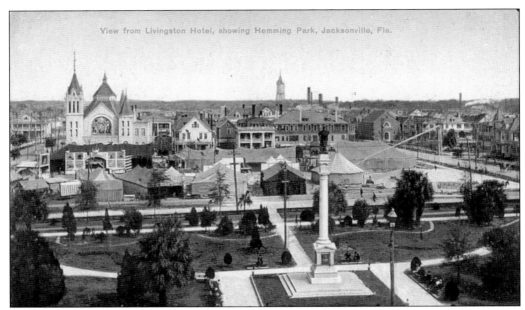

The area surrounding Hemming Park experienced a rapid rebirth after the 1901 Fire. However, the land where Cohen Brothers Department Store opened in 1912 sat vacant for nearly a decade. In this northerly view toward Springfield, the eventual Cohen Brothers parcel is in temporary use as circus grounds. To the north are First Baptist Church and, in the distance, the tower at Waterworks Park.

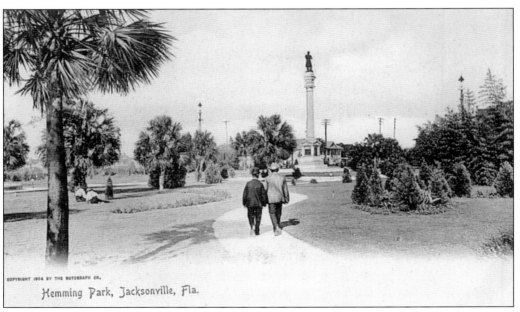

COPYRIGHT 1904 BY THE ROTOGRAPH CO.

Hemming Park, Jacksonville, Fla.

The dominant feature in Hemming Park is the Confederate Statue. At the statue's 1898 dedication, Gen. Fitzhugh Lee and Gen. U.S. Grant's grandson represented the armies of the North and the South. In that same year, the city council re-named the park "Hemming Park" to honor Jacksonville resident and Confederate veteran Charles C. Hemming, who gave the statue to the city. The streets bordering the square are Hogan, Laura, Duval, and Monroe.

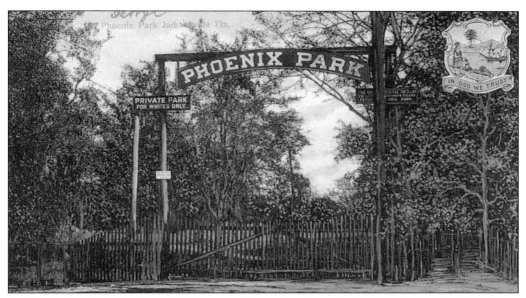

On September 21, 1901, Phoenix Park opened in conjunction with the extension of the Main Street streetcar line to the park. The park, northeast of Springfield, was named "Phoenix" to commemorate the city's "rise from ashes" following the 1901 Fire. In 1912, the ostrich farm moved to the park, creating a major Jacksonville tourist attraction. The sign at the gate stating, "whites only" gives witness to the South's Jim Crow era. The streetcar company opened another park, Mason Park, for African Americans. (Courtesy Bob Basford.)

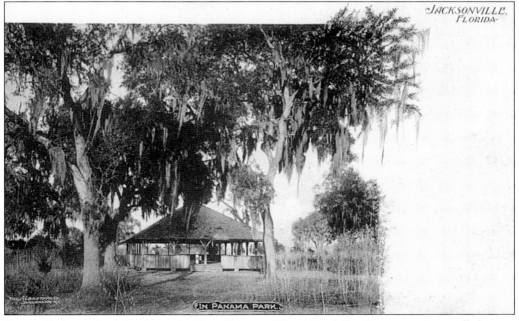

Panama Park, north of the city at the Trout River or "Trout Creek," as it was sometimes called, was a popular area for sailing and picnicking. For many years, the Panama Park area was the end point of the East Jacksonville shell road and Pine Street's (Main Street) sawdust road.

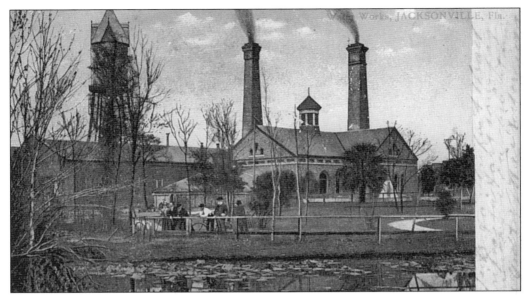

Waterworks Park got its start in 1879 as the city's first major water source. It was later the site for the 1888 extravaganza, the Subtropical Exposition. Thousands, including President Grover Cleveland, flocked to the exposition that featured a grand pavilion, a Seminole Indian camp, two artificial lakes, a zoo, and subtropical products. The exposition was staged to help Jacksonville retain winter tourist trade, a staple of the city's economy. After four seasons, the exposition closed and the area became a park, including the 1896 Waterworks Building, pictured here *c.* 1903.

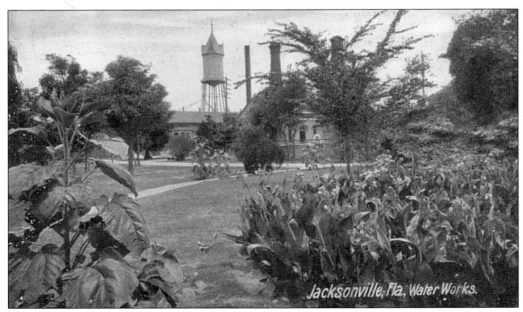

For many years "Big Jim," located at the waterworks, was the commanding copper whistle that awakened the city daily. "Big Jim" also signaled noon and 5 p.m. Jacksonville resident John Einig, who also held the distinction of assembling and owning Jacksonville's first automobile, designed "Big Jim." The whistle, named for Jim Patterson who cast it in 1880, was funded from public subscription by local labor unions.

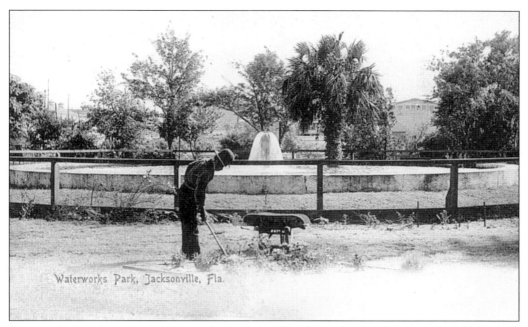

Waterworks Park, Jacksonville, Fla.

Waterworks Park is perched on the northern edge of First Street, joining downtown and Springfield. The park became part of a series of parks; it was located between turn-of-the-century Springfield Park and the 1907 Dignan (now Confederate) Park.

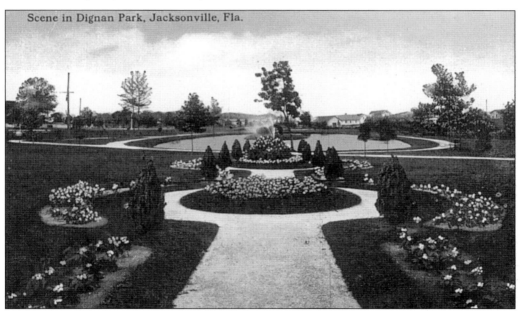

Scene in Dignan Park, Jacksonville, Fla.

Main and Hubbard Streets, with Hogan's Creek to the south, border Dignan Park. Dignan Park opened in 1907, boasting the city's first playground. In 1914, Jacksonville hosted nearly 50,000 aging Confederate veterans, many of them camping in Dignan and Springfield Parks. Afterward, Dignan Park was renamed Confederate Park. The Florida Division of United Confederate Veterans commissioned the park's monument commemorating the women of the Confederacy.

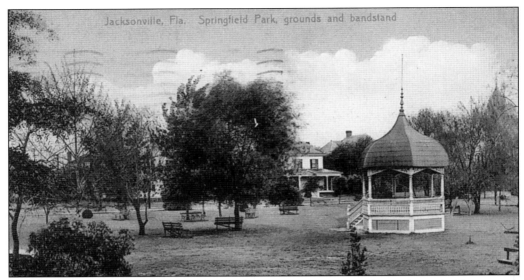

In 1898, the Springfield Company deeded the city 40 acres of land north of Hogan's Creek. The property was named Springfield Park. In 1914, a city zoo was established at Springfield Park with one red deer. By year's end, the zoo population was thriving with raccoons, wildcats, alligators, monkeys, rabbits, wolves, chickens, white rats, owls, pigeons, canaries, opossums, a guinea pig, and a parrot. After some Springfield residents protested the menagerie of animals, the zoo was moved to Trout River where it is still located today.

Hogan's Creek was named for Lewis Hogan, an early settler who pre-dated Jacksonville's 1822 founding. Springfield Park was one of three parks bordered by the creek. Flooding was a problem for decades. Ultimately, architect Henry Klutho and engineer Charles Imeson designed a drainage project for the Hogan's Creek area. Footbridges, lakes, lighting, and balustrades created a "Grand Canal" along Springfield Park, Waterworks Park, and Confederate Park. In 1984, the original portion of Springfield Park was renamed in Klutho's honor. The distant steeple of Bethel Baptist Institutional Church can be seen in this view.

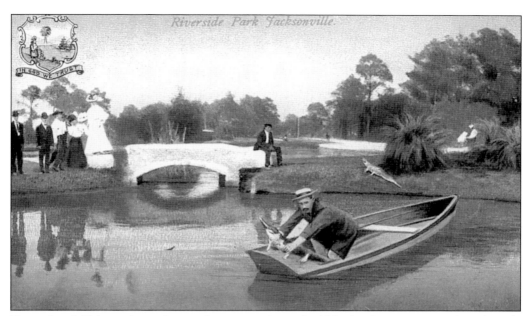

Five spring-fed lakes and a carriage road were carved out of a thick pine forest to create Riverside Park. The idea for a 14-acre park at this location originated in 1869 in John M. Forbes' plat of 500 acres that came to be known as "Riverside." In the park's early years, cattle still freely roamed the Riverside area. A fence with turnstiles was used to keep the grazing livestock from entering the park.

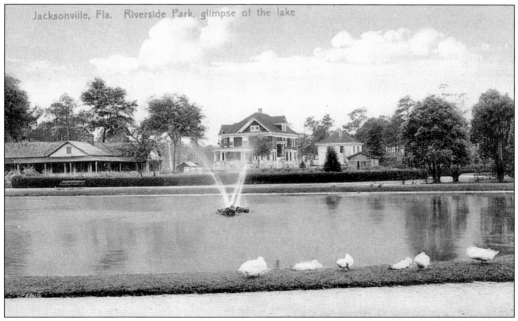

Jacksonville, Fla. Riverside Park, glimpse of the lake

Over the years, four of the five Riverside Park lakes were filled in, and the park was reduced in size. Today's boundaries include Park, Post, Margaret and College Streets and Interstate 95. A commercial district that boomed through the early 20th century, and later the interstate highway, replaced much of the area's original residential quality. (Courtesy Bob Basford.)

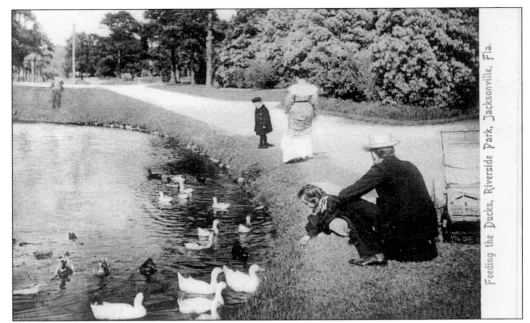

Feeding ducks was a favorite pastime of visitors of Riverside Park. The carriage road running next to this lake (and all other carriage roads in the park) was closed to automobile traffic in 1931. It seems that "young men speeding through the park at twenty miles an hour" frightened the strolling ladies.

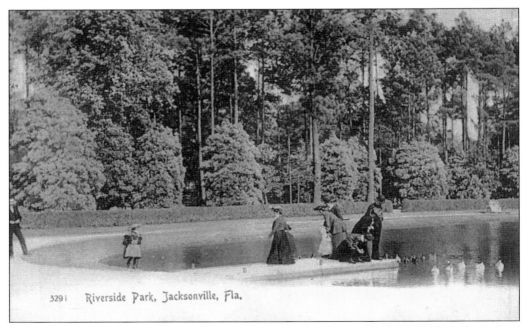

329i Riverside Park, Jacksonville, Fla.

As a teenager, Mellen C. Greeley helped clear the forest of trees to establish Riverside Park. He later became a noted Jacksonville architect; his design work was imprinted on a number of noteworthy Riverside structures, including the Woman's Club of Jacksonville and the remodeling of the Church of the Good Shepard.

Eight

ENVIRONS

Between 1901 and 1914, there were no Avondale, San Marco, or San Jose neighborhoods. Ortega was reachable by trolley. The Ortega Company platted lots in that neighborhood in 1909, and a riverfront parcel could be purchased for $100. Arlington and Mandarin existed and prospered long before World War I; but neither was conveniently accessible to Jacksonville, except by water. Atlantic Beach boasted Henry Flagler's Continental Hotel, which opened one month after the Great Fire. Jacksonville Beach was known as Ruby Beach until the mid-1880s, and then as Pablo Beach until 1925. Paving of Atlantic Boulevard was not completed until 1910. Beach Boulevard would not be completed for almost 40 years after that. Today, we take our mobility for granted; but the following postcards show us neighborhoods that once seemed worlds apart from Jacksonville.

In 1882, a company was chartered to build a streetcar line on Pine Street (now Main) from Bay Street to what is now Eighth Street in Springfield. Springfield was then considered "out in the woods." The cars were originally drawn by mules. The first electric streetcar in Jacksonville was run on the Main Street line February 24, 1893. A network of Jacksonville "street railway cars" thrived during the first part of the 20th century.

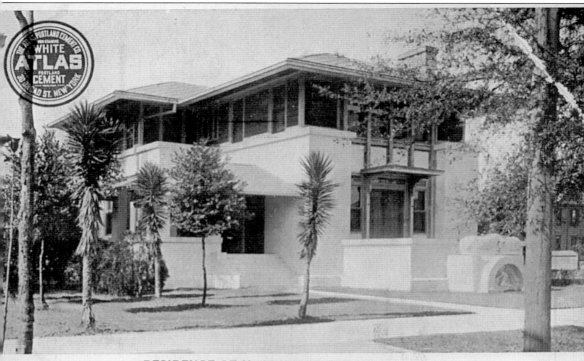

RESIDENCE OF H. J. KLUTHO, JACKSONVILLE, FLA.

KLUTHO, ARCHITECT F. M. RICHARDSON, CONTRA

This postcard shows Henry John Klutho's residence. The residence of this Frank Lloyd Wright disciple and Prairie School pioneer was originally located at 2018 Main Street. Klutho moved the home to its present location, 30 West Ninth Street, and converted it to apartments. He resided in the home for many years. It is now being renovated. Klutho is described as the most influential post-Fire architect in Jacksonville.

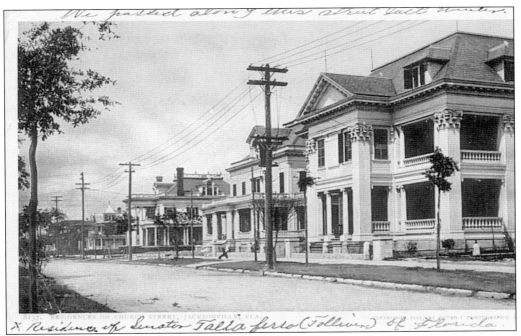

"X" marks the home of United States Sen. James P. Taliaferro. Also shown (to the left of Senator Taliaferro's home) is the Thomas V. Porter residence. The Porter home was designed by architect Henry J. Klutho and constructed in 1902. It survives today as the headquarters of a prominent architecture firm.

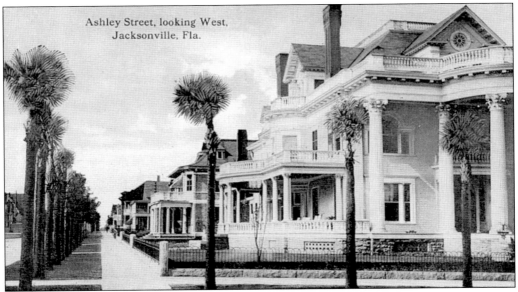

These stately Ashley Street homes show the character and quality of Springfield, Jacksonville's premier neighborhood at the beginning of the 20th century. Notice the absence of any overhead electrical and telephone wires, suggesting these conveniences had not been installed at the time this photograph was taken.

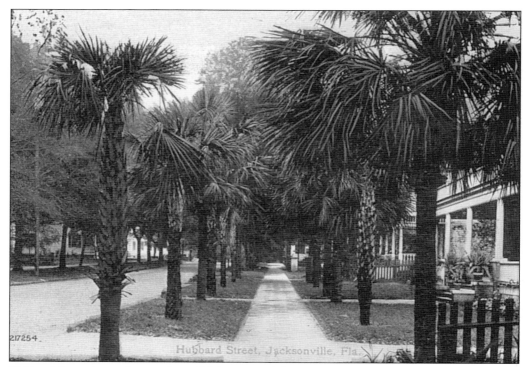

Hubbard Street boasted many beautiful homes and this inviting palm canopy. Although there are sidewalks, Hubbard Street itself does not appear to be paved in the view. (Courtesy Bob Basford.)

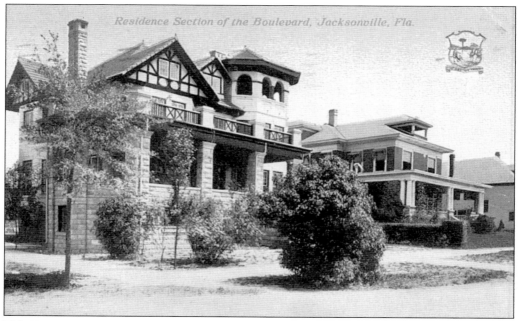

This H. & W.B. Drew "Florida Artistic Series" postcard was mailed February 16, 1913. "Weather nice and warm everything a hustle at depot," says the correspondent.

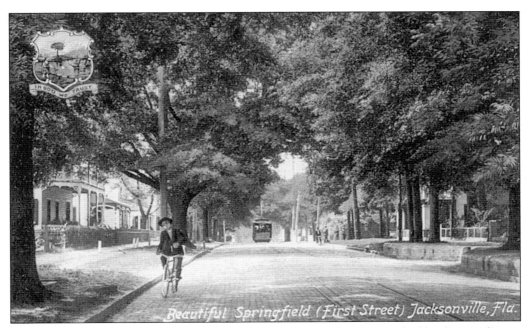

This early view of First Street shows pedestrians, the electric railway car, and a bicyclist traveling to their respective destinations. First Street is constructed of brick. This card and the one below were both published by M. Mark of Jacksonville, Florida.

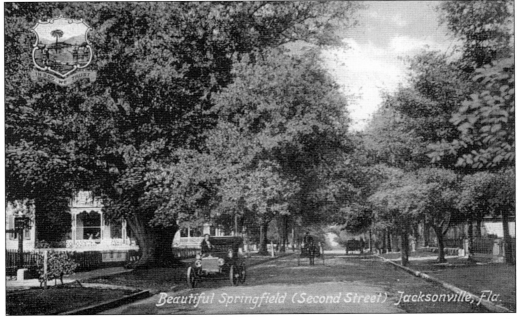

This view takes us one block north of First Street to Second Street in "Beautiful Springfield." An early automobile and two horse-drawn wagons each negotiate their way through the leafy canopy.

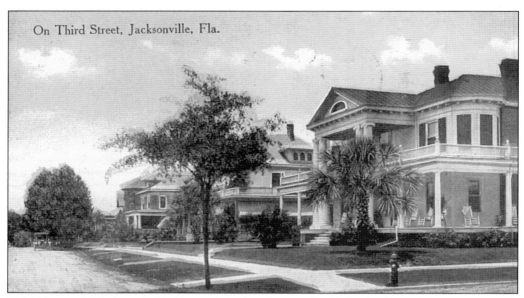

On Third Street, Jacksonville, Fla.

This February 1914 view of Third Street shows it to be considerably less landscaped than contemporary First and Second Streets (as shown in the two preceding views). Third Street does not appear to be paved. Nevertheless, stately homes line the block; a modern-looking fire hydrant and paved sidewalks have been installed. The writer of this postcard reports that she "visited the Ostrich Farm on Thursday."

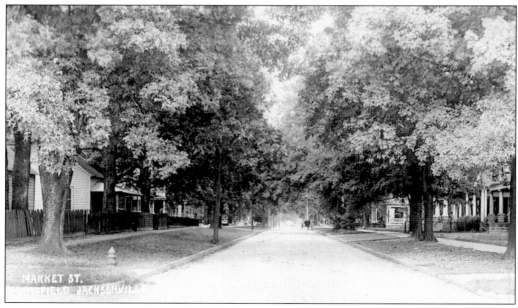

This "real photo" card depicts Market Street in the Springfield area. A fancy horse-drawn cab approaches from the distance. (Courtesy Bob Basford.)

Although Riverside and Avondale are often mentioned today in the same breath, Avondale was not developed until the 1920s. In 1868, John M. Forbes, a Boston millionaire, paid $10,000 in gold for 500 acres near downtown Jacksonville. The property was platted for Forbes into lots on February 1, 1869, and named Riverside. Riverside has been an established residential neighborhood since the 1890s; however, its popularity and prominence rapidly increased following the Great Fire of 1901. (Courtesy Bob Basford.)

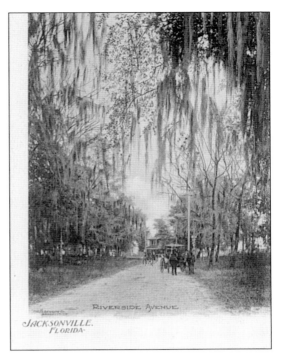

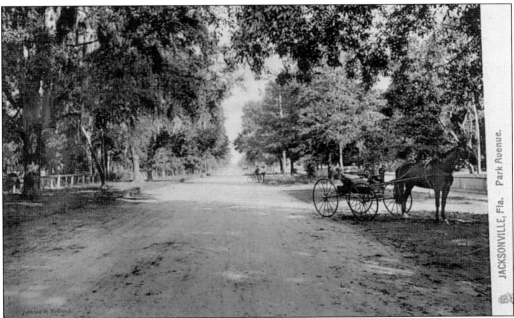

Another Riverside Avenue view gives a taste of the area's sophisticated style and landscaping. This pre-1907 "Raphael Tuck" card was printed in Holland. The caption reads, "Park Avenue is one of the chief of beautiful drives, and is so called because it runs parallel with Riverside Park. It is bordered on both sides with fine old trees, from the branches of many of which is a natural growth of moss that gracefully sways with each passing breeze."

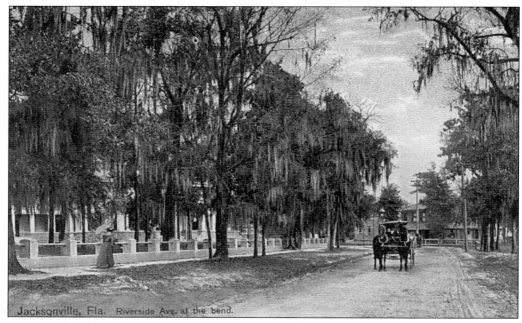

"The city is laid out into broad avenues shaded by grand live oaks, whose branches are draped and festooned with long streamers of the beautiful Spanish Moss. Rare flowers and shrubbery of the tropics adorn the grounds of the numerous villas and hotels. The picture shows Riverside Avenue at the Bend, one of the most attractive residential streets."

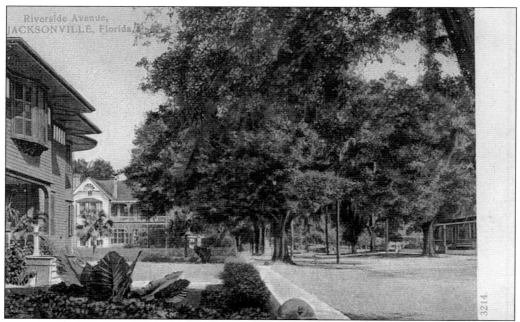

Riverside Avenue is lined with posh homes on this undivided back postcard, which was printed in Germany for New York's A.C. Bosselman & Co.

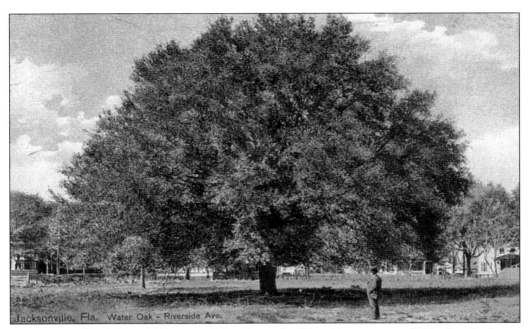

The reverse side of this *c.* 1910 postcard that shows the Riverside area states, "This city, the largest in Florida, and its principal distributing point for Winter tourist travel, is situated upon the left bank of the St. Johns River 25 miles from the sea . . . The oak tree shown in the picture is the largest and most symmetrical in Jacksonville." (In 1910, South Jacksonville had not yet been incorporated into the Jacksonville city limits. It was home to the larger tree, now known as the "Treaty Oak.")

Fishweir Creek (formerly Fishware Creek) was generally considered the border between Ortega (to the south) and Avondale (to the north). The property nearby was platted in 1882 into areas known as Shadowlawn, Arden, and Fishweir Park. Water hyacinths cover much of the creek's surface in this 1907 card.

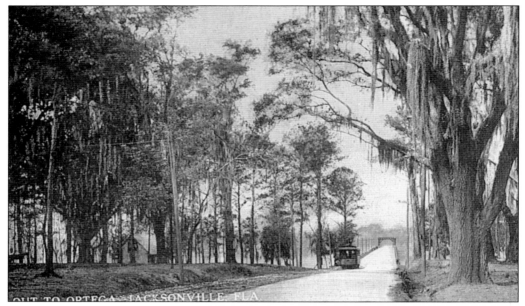

The name "Ortega" dates from 1804; however, this prominent Jacksonville suburb was cultivated and operated as an important plantation from as early as the 1760s. The Ortega Company platted the subdivision in 1909. That same year, the Ortega Company completed an electric railway line from Ortega to connect with the line of the Jacksonville Electric Company at Aberdeen Avenue. This H. & W.B. Drew postcard depicts one of those railway cars on its appointed rounds.

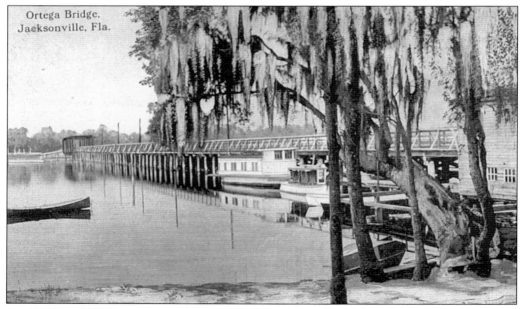

A *c.* 1914 H. & W.B. Drew view of the Ortega Bridge is shown above. The trolley traversed this wooden bridge on its way to and from downtown. The wooden bridge was replaced in 1927 by a concrete bridge.

Just across the St. Johns River from Jacksonville lay "South Jacksonville." The town was incorporated in 1907. The railroad ran through South Jacksonville and Atlantic Boulevard (completed in 1910) provided a highway from South Jacksonville to Pablo Beach (later Jacksonville Beach). South Jacksonville was not incorporated into the City of Jacksonville until 1932.

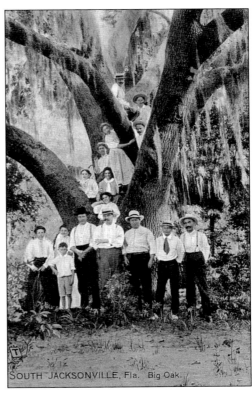

The tree pictured on this Raphael Tuck postcard is purported to be the "Big Oak," which later became known as the "Treaty Oak." The real "Big Oak" was located within the bounds of Dixieland Park, which opened in South Jacksonville in 1907. This picture bears little resemblance to the actual "Big Oak." Compounding its error, Tuck has quoted (on the card's reverse) the plaque Dixieland Park officials attached to the "real" Big Oak which erroneously claimed the tree "was Osceola's favorite camp ground and was generally used for Indian Councils of War." The "real" Big Oak/Treaty Oak thrives today in the Jessie Ball duPont Park near the Southbank. (See postcard on page 116.)

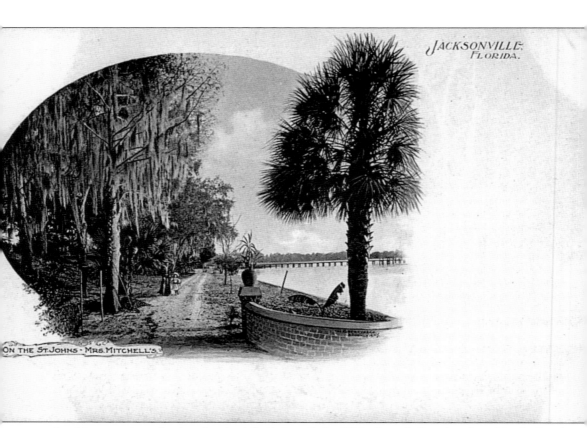

ON THE ST. JOHNS - MRS. MITCHELL'S

JACKSONVILLE, FLORIDA.

San Marco was not developed and subdivided until the 1920s. Long before that time, Martha Reed Mitchell constructed "Villa Alexandria." Her brother Harrison Reed was governor of Florida shortly after the Civil War, and her husband, Alexander Mitchell, was a Milwaukee railroad mogul. Dating from the early 1870s, it was Mrs. Mitchell's winter home. The home and grounds were lavishly furnished, and Mrs. Mitchell, who was an influential and well-regarded citizen of Jacksonville, entertained internationally famous guests there. She is buried in the old St. Nicholas Cemetery. The River Road area, where Villa Alexandria was located, continues to be one of Jacksonville's most prestigious residential communities.

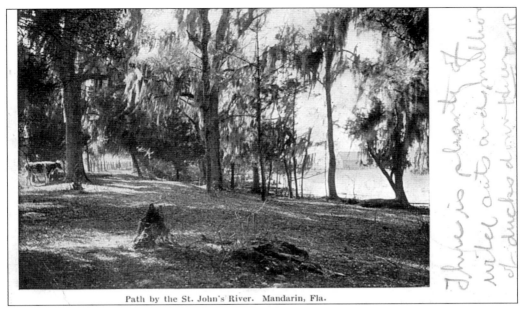

Path by the St. John's River. Mandarin, Fla.

Mandarin is now a bustling and prosperous Jacksonville suburb. Its roots, however, date back hundreds of years to the Timucuan Indians. Between the 1760s and the 1820s, the Mandarin area was handed back and forth between the Spanish and the British, as those two countries vied for control of Florida. Spain finally ceded Florida to the United States in 1821. Mandarin's name derives from the Mandarin oranges that were cultivated in the vicinity. A United States Post Office was opened there in 1830.

"St. Johns Avenue" is now known as Mandarin Road. This oak-draped avenue has long been symbolic of Mandarin, and the Live Oaks (designated by the Jacksonville City Council in 1987 as Mandarin's "Patriarch Oaks") continue to majestically rule. Their existence is constantly threatened by the burgeoning population. Developers, and even government officials, aspire to lay water and sewage lines through the middle of the root networks vital to these trees.

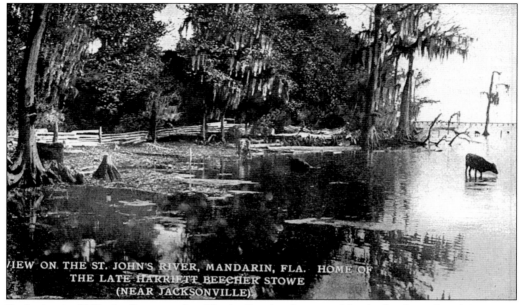

VIEW ON THE ST. JOHN'S RIVER, MANDARIN, FLA. HOME OF
THE LATE HARRIET BEECHER STOWE
(NEAR JACKSONVILLE).

Beginning in 1868, the famous author Harriet Beecher Stowe and her husband, Prof. Calvin Stowe, wintered in Mandarin. In 1872, Mrs. Stowe concluded an account of a walk in Mandarin: "But now the sun falls west, and we plod homeward. If you want to see a new and peculiar beauty, watch a golden sunset through a grove draperied with gray moss. The swaying, filmy bands turn golden and rose colored; and the long swaying avenues are like a scene in fairy land."

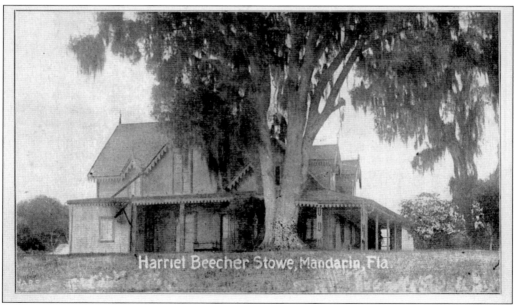

Harriet Beecher Stowe, Mandarin, Fla.

Mrs. Stowe wrote numerous articles about Mandarin, and published *Palmetto Leaves*, a book of anecdotes about her Florida life. Her enormous influence attracted great attention to Florida and little Mandarin. Although the home depicted in this view no longer exists, the live oak tree around which the veranda wrapped still thrives.

Professor and Mrs. Stowe were both deeply religious. Mrs. Stowe's brother Henry Ward Beecher was a world-renowned preacher. Professor and Mrs. Stowe were instrumental in organizing a group and obtaining funds to construct the Church of Our Saviour building in 1883. The window shown in the left (westerly) wall of the church was designed as a memorial to the Stowes by Louis Comfort Tiffany. The window and church building were destroyed by Hurricane Dora in 1964.

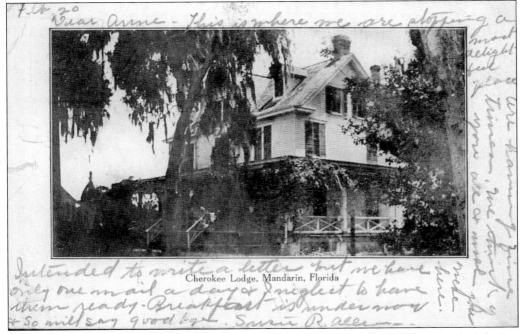

Cherokee Lodge, Mandarin, Florida

This February 1908, card depicts "Cherokee Lodge" in Mandarin. This correspondent says she is having a "fine time" and because there is "only one mail a day," she neglects to have time to prepare letters to mail. "Breakfast is under way now," our energetic writer says, "and so will say goodbye."

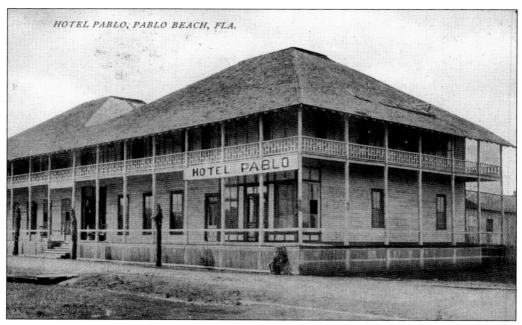

HOTEL PABLO, PABLO BEACH, FLA.

HOTEL PABLO

This postcard, mailed in August 1908, features the rustic porches of the Hotel Pablo. The hotel's name reflected the town's name, changed from Ruby Beach to Pablo Beach in 1886. The name Pablo Beach was changed to Jacksonville Beach in 1925. On April 9, 1914, the Hotel Pablo and 11 houses in the heart of the town burned to the ground. (Courtesy Bob Basford.)

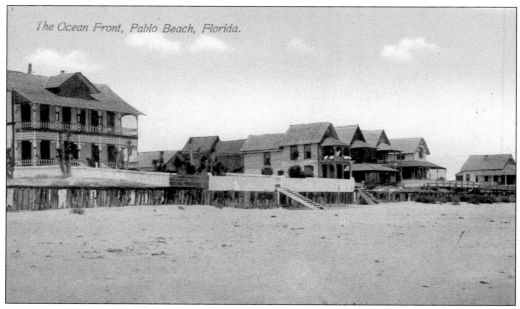

The Ocean Front, Pablo Beach, Florida.

The Ocean Front Hotel at Pablo Beach was popular with tourists and Jacksonville residents alike. Travel from Jacksonville was typically by train. In late 1884, a narrow gauge rail, known as the Jacksonville & Atlantic Railway was completed from South Jacksonville to Pablo Beach. The line was extended to Mayport in 1899. (Courtesy Bob Basford.)

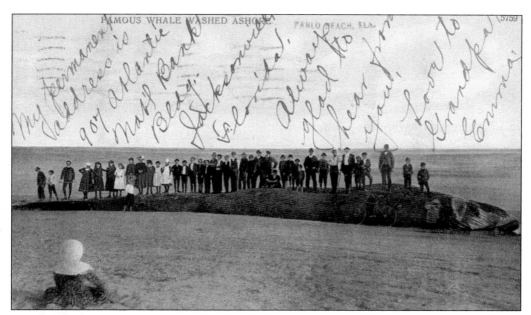

An enormous whale washed ashore on Pablo Beach. More than 40 individuals stand side by side on the whale to prove its sheer size. This postcard was mailed 1910, the same year Atlantic Boulevard opened from South Jacksonville to Mayport Road. Two decades in the making, Atlantic Boulevard was begun in 1892 using convict labor. (Courtesy Bob Basford.)

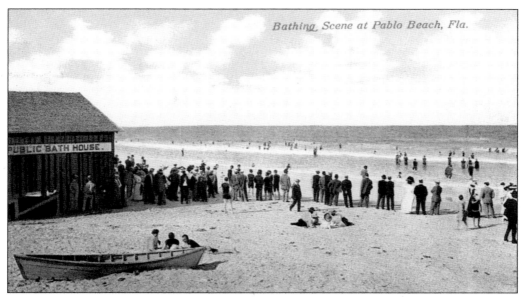

In the early 20th century, recreation and leisure time were changing the face of Jacksonville and the beaches. Suddenly, amusement parks, films, and beach activities were part of the city's culture. Thousands crowded the beach on weekends, and families "summered" for weeks in the ocean breezes of the east coast. As beach activity increased, eight trains a day departed South Jacksonville for the beach. By 1932, when automobiles ruled local travel, the train line closed. This right of way was later given to the State of Florida, and in 1949 Beach Boulevard opened along the old train route.

Surf View at Pablo Beach, Fla.

Young boys, men, and a "few" women frolic in the waters of the Atlantic Ocean at Pablo Beach. The popularity of "public bathing" created a need for ocean safety, and on April 6, 1913, the U.S. Life-saving Corps established a life saving station at Pablo Beach. The corps included 19 volunteers, a boat patrol, and lifelines. Today, the corps boasts the oldest volunteer life-saving beach patrol in the nation.

The Barbecue, Pablo Beach. Florida.

On this 1912 card, the sender writes, "You bet I'm having a good time in the ocean." The popularity of the beach, including golfing, picnicking, tennis, and dancing, grew with automobile access to the area. (Courtesy Bob Basford.)

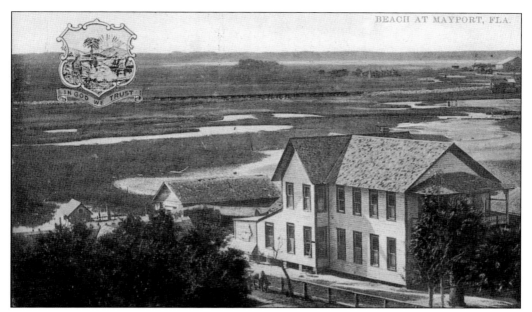

Mayport was among the earliest fashionable beach destinations of Jacksonville residents. Prior to 1888, travel to Mayport required a tedious boat trip and, perhaps, the use of a buggy on the final leg of the venture. The Jacksonville, Mayport & Pablo Railway (JM&P) began service in 1888. (Courtesy Bob Basford.)

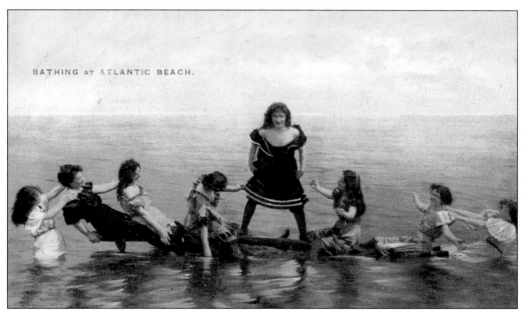

Eye-catching female bathers were a matter of concern to lawmakers. At the time of this 1907 card, the adoption of the 19th amendment, which gave women the right to vote, was still 13 years away. Of more immediate concern was the beachwear of the era. The town of Pablo eventually hired a female police officer to enforce proper attire for female "bathers." One of the strictly imposed rules was a stocking requirement for women. (Courtesy Bob Basford.)

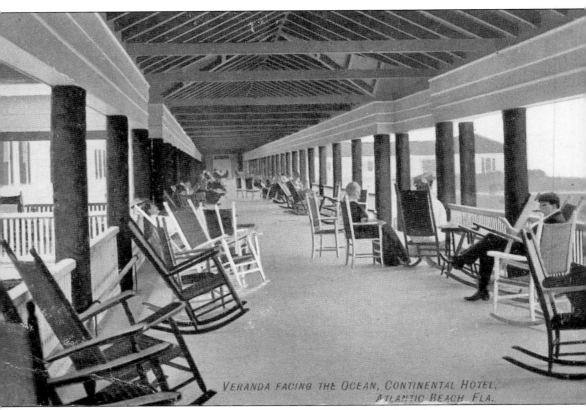

VERANDA FACING THE OCEAN, CONTINENTAL HOTEL, ATLANTIC BEACH, FLA.

On this card postmarked August 1907, the sender says, "The veranda in the picture is about 200 feet long, filled with rocking chairs. You can keep cool here." The extensive veranda was a prominent feature of the Continental Hotel at Atlantic Beach. The hotel opened in 1901, only weeks after the Great Fire. It featured an oceanfront promenade 16 feet wide and 1,100 feet long. (Courtesy Bob Basford.)

Nine

JACKSONVILLE IS AMUSED

In January 1912, more than 200 ostriches moved into the "New Ostrich Farm, Amusement Park and Zoo." They were soon joined by "Alligator Joe" and his reptilian herd. The new facility was located on what is now Talleyrand Avenue at the former site of Phoenix Park. The ostriches had resided just across the street since the 1890s. Jacksonville's Evening Metropolis *opined that the new facility "is more than an amusement park . . . There will be thrown open to the public a veritable fairyland . . . It will be quite impossible for any visitor to our state to complete his trip without visiting this resort." Who are we to argue? The following scenes depict Jacksonville's Ostrich and Alligator Farm, South Jacksonville's Dixieland Park, and, of course, "Old Joe."*

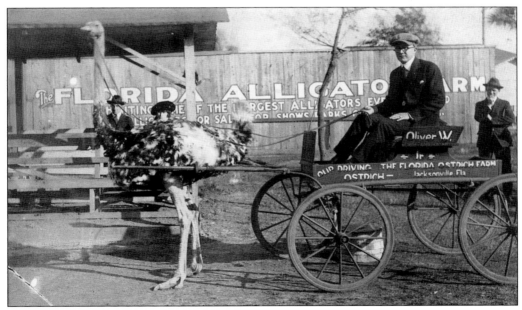

Joseph "Alligator Joe" Campbell established what is thought to be the first alligator farm in 1891. His Florida Alligator Farm was located on what is now the site of the Prudential Insurance complex. Alligator Joe eventually merged his operation with that of Charles Fraser's Florida Ostrich Farm. The Ostrich Farm featured "Oliver W.," the famous racing ostrich shown here.

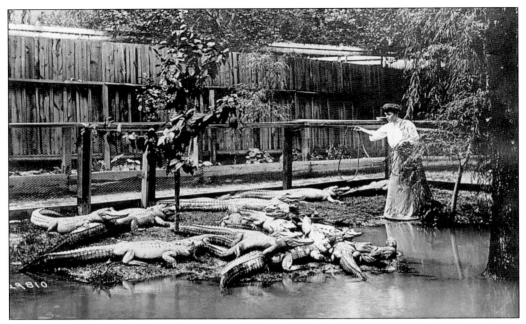

In this 1908 card, a dozen or so alligators cast their attention on a subject of apparent interest to them. Who is trying to catch whom? (Courtesy Bob Basford.)

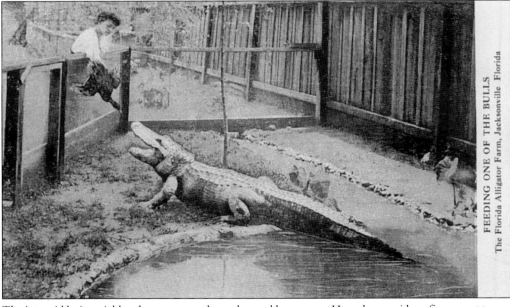

FEEDING ONE OF THE BULLS
The Florida Alligator Farm, Jacksonville Florida

The intrepid lariat wielder above apparently made good her escape. Here she provides a fine repast to one of the Florida Alligator Farm's bull gators. An alligator has 60 to 70 teeth, used mainly to clamp on to its food, which is then swallowed whole.

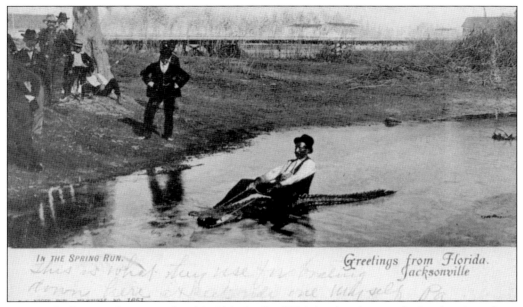

Greetings from Florida.
Jacksonville

In 1909, "Pa" wrote this postcard to his Ohio family: "This is what they use for boating down here. Expect [to] ride one myself." History does not record whether "Pa" fulfilled his ambition. (Courtesy Bob Basford.)

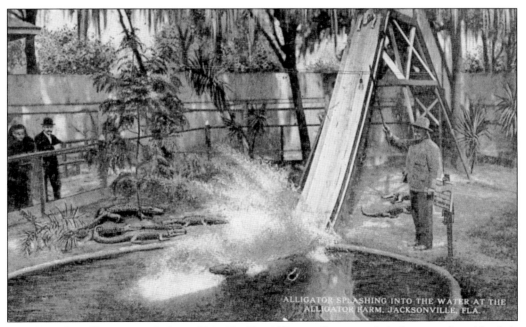

By 1914, the alligators at Jacksonville's Florida Alligator Farm regaled the crowds with their diving exploits.

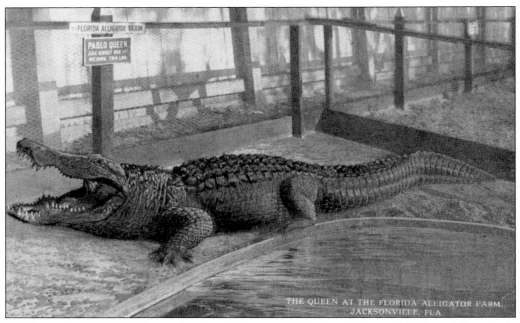

The sign reads, "The Pablo Queen. Age about 250 years. Weighs about 784 pounds." The weight estimate was likely accurate; however, skeptics might question the Queen's alleged A.D. 1650 birth date.

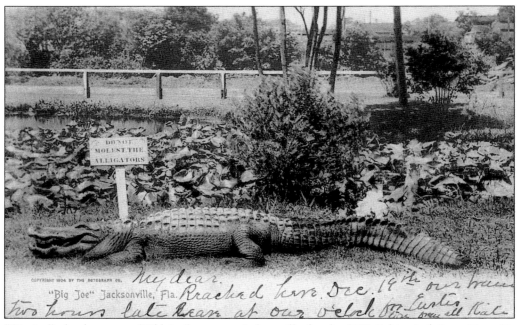

"Big Joe" also known as "Old Joe" came to Jacksonville for the 1888 Subtropical Exposition. He thereafter resided for some years in this pond at Waterworks Park and afterward at Hemming Park. He was over 10 feet long. This postcard was mailed in 1904.

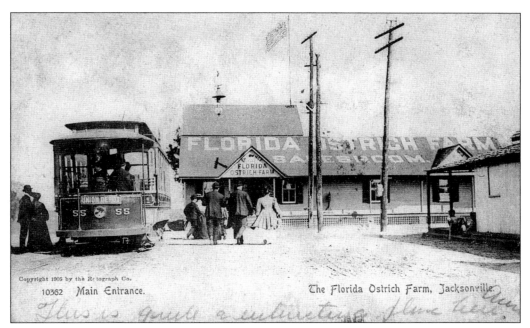

Copyright 1905 by the Rotograph Co.
10362 Main Entrance. The Florida Ostrich Farm, Jacksonville.

Ostrich farming in Florida dates from 1898, when Charles D. Fraser opened an ostrich farm in Jacksonville's Fairfield neighborhood. According to a Florida Ostrich Farm brochure, "The farm, which is beautifully situated on the St. Johns River, is reached by the electric cars or by the beautiful shell road drive on Talleyrand Avenue."

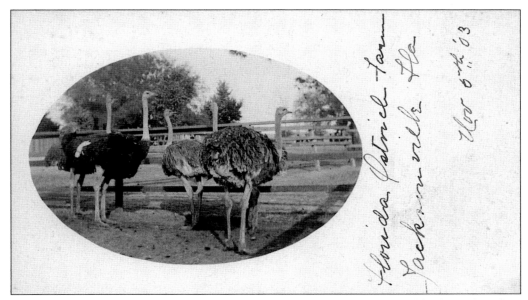

"Our farm now contains over two hundred ostriches, ranging from gigantic old birds standing from seven to ten ft. high and weighing from two hundred and fifty to four hundred pounds each, to the little chicks just out of the shell." (Florida Ostrich Farm brochure.)

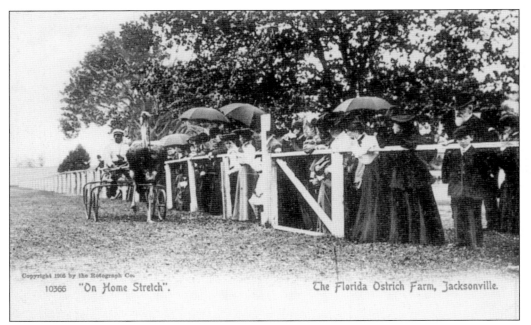

10366 "On Home Stretch". The Florida Ostrich Farm, Jacksonville.

The Florida Ostrich Farm billed "Oliver W" as "positively the only harness-broken ostrich in America." His record (for the mile?) was listed as "2.02." "Oliver W." provided daily exhibitions in Jacksonville during the winter tourist season, but he summered "in the North."

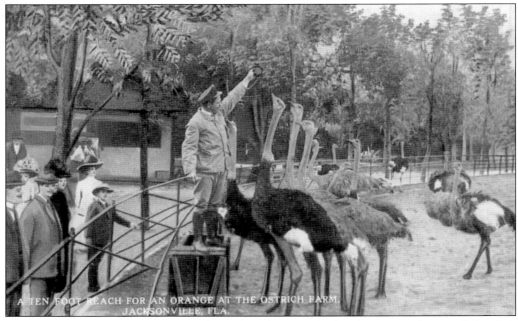

A TEN FOOT REACH FOR AN ORANGE AT THE OSTRICH FARM, JACKSONVILLE, FLA.

"Experience has shown that they thrive famously in their corrals, that they grow as large, and that their feathers are as good in quality and as large in size as those of the Cape (South Africa)." (Florida Ostrich Farm brochure.)

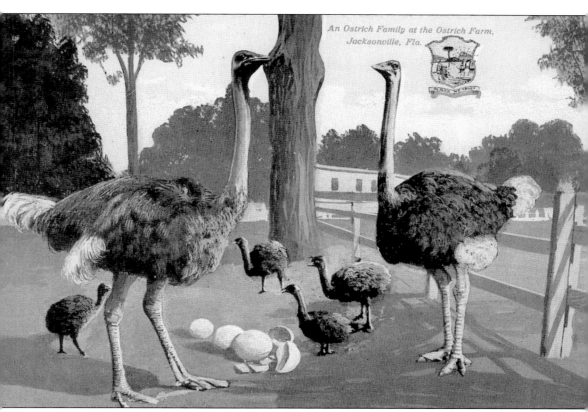

"During the laying season the males become very fierce and can dangerously wound a man with one blow of the foot; they kick forward, with a downward, scratching, movement, and their one sharp claw is sometimes fatal. Should anyone be so unfortunate as to find himself near a savage bird, a certain amount of safety can be secured by lying flat on the ground, as the ostrich can kick dangerously only at a height of about three feet; this is probably the reason these birds are so frightened at a dog; although they will charge a man on horseback, yet a little fox terrier will send them running to the farthest corner of the field." (Florida Ostrich Farm brochure.)

Baby Ostriches, Florida.

"An ostrich egg weighs about three and one-half pounds, and is equal to about thirty hen eggs; an omelette of ostrich eggs is nearly the same flavor and appearance as an omelette of ordinary eggs." (Florida Ostrich Farm brochure.)

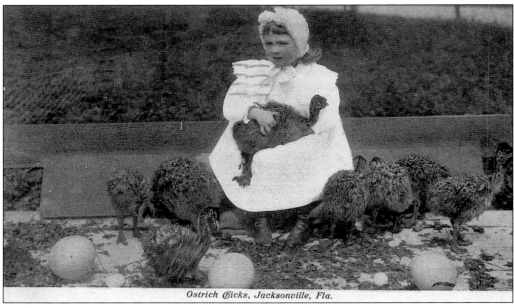

Ostrich Chicks, Jacksonville, Fla.

"When the chicks are taken away (from their mothers) they are kept warm at night in well covered boxes; on the third day after their appearance, they will begin devouring small stones and broken bone; on the fourth or fifth they begin to eat bran, cabbage, grass, etc. which is the ideal food for the bird in its younger state. With this its mortality is small and growth remarkably fast; up to the age of six months it grows at the rate of one foot a month." (Florida Ostrich Farm brochure.)

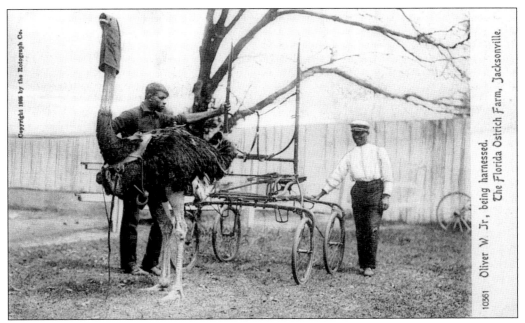

10361 Oliver W. Jr., being harnessed.
The Florida Ostrich Farm, Jacksonville.

"My dear Helen, Saw Oliver W. Jr. this Saturday morning, March 2, '07. How I wished you were with me—it is so interesting. About 100 birds, saw nests of from 1 to a dozen eggs—15 to 18 is usual number. Saw many alligators, some very large, and many other wild animals. Am very much obliged for that nice letter. Do not forget to write again—Love to all—your uncle Ralph."

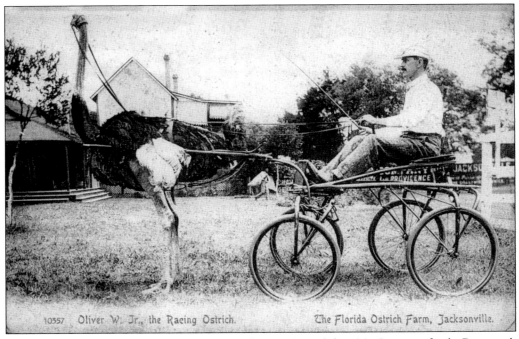

10357 Oliver W. Jr., the Racing Ostrich. The Florida Ostrich Farm, Jacksonville.

This undivided back postcard was printed (as was the one pictured above) in Germany, for the Rotograph Co. of New York City.

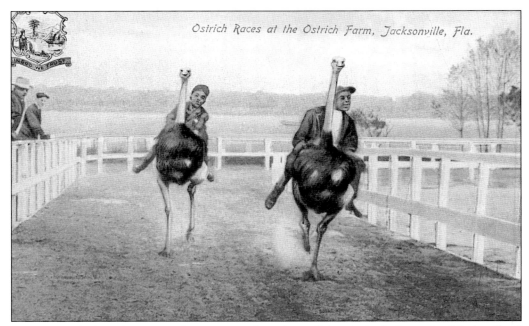

Ostrich Races at the Ostrich Farm, Jacksonville, Fla.

This divided back card was printed in Germany for Jacksonville's H. & W.B. Drew Co. "Cyclone" and "Prince of Wales" were two "Running Ostriches," and may be the ones pictured here.

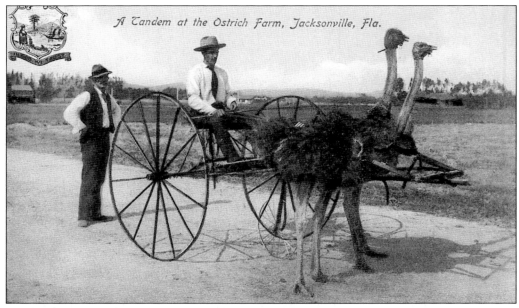

A Tandem at the Ostrich Farm, Jacksonville, Fla.

In another German card, printed for H. & W.B. Drew Co., the Ostrich Farm displays its ability to harness two birds to a sulky. The degree of concentration evident on the driver's face underscores the difficulty of maneuvering this pair.

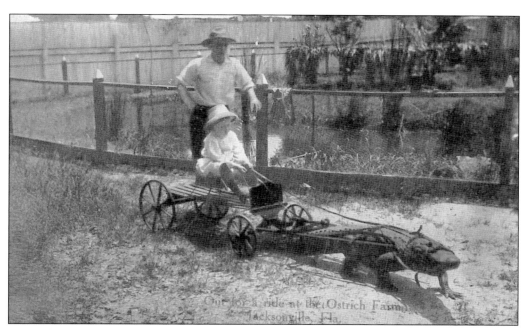

Not to be outdone by his ostrich-driving elders (on the preceding pages) this bold youth bends an alligator to his will. Uncorroborated reports suggest this card may be an early photo of Florida State University football coach Bobby Bowden.

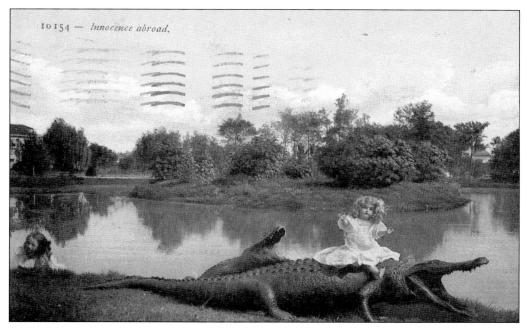

In this 1910 card, our correspondent tells her recipient in Illinois, "They are so gentle they would not hurt a little child in Jacksonville."

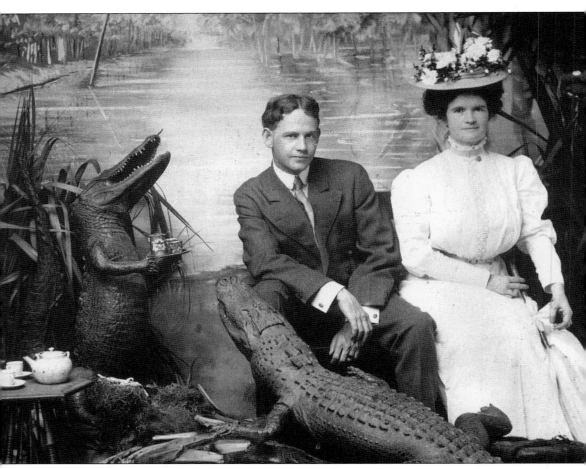

Many "real photo" postcards were made from photographs staged at the Alligator and Ostrich Farms. In this early 20th-century view, Herbert Aubrey Carrell and his sister Verena Fluella Carrell (Mrs. Jack Hurt) are bedecked in Sunday finery as they enjoy high tea with friends.

J.H. Hollingsworth, a tourist photographer, took this early 1900s "real photo" card of Joseph W. Ripley and Wayne Ripley. The Ripleys were prominent citizens of South Jacksonville, residing at a riverfront estate near what is now Lakewood. The Ripley family has spawned legislators, judges, and state attorneys. Many Ripley descendants remain residents of Jacksonville.

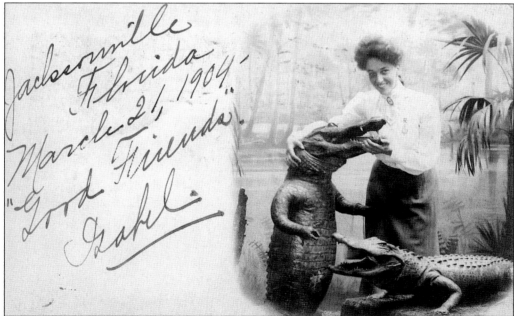

This "Private Mailing Card" regaled "Isabel's" folks back home in Massachusetts. Jacksonville's oft-photographed alligators never failed to turn on the charm for a camera. (Courtesy Bob Basford.)

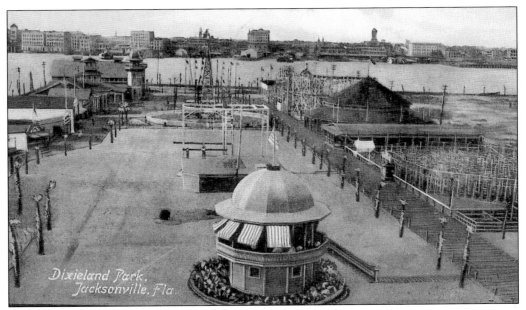

Dixieland Park had a brief heyday (from 1907 to 1908) in South Jacksonville. "This was an attempt to afford a place of general amusement for the people of Jacksonville and vicinity, a place where entertainments, fairs, theatricals, athletics, and contests of every character could be held." (T. Frederick Davis.)

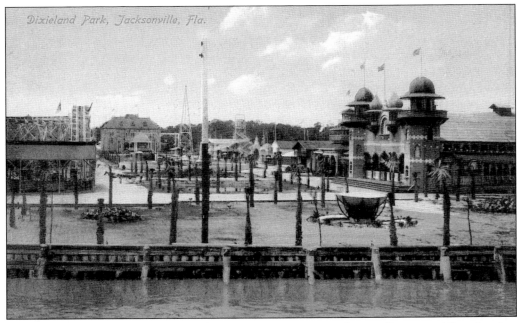

"When finally completed [Dixieland Park] was an attractive resort and was well supported for a time; but when the novelty wore off, it began to go down and finally collapsed." (T. Frederick Davis.) (Courtesy Bob Basford.)

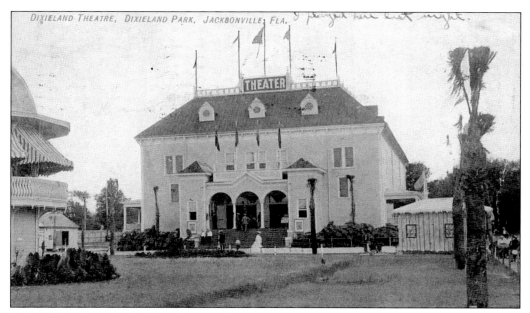

"I played here last night." Although postmarked June 23, 1909, the writer dates the card "June Skiddooth, 1909." "I am writing this at supper table. This dining room is on an upstairs porch on the main street; it is fine to sit here in the cool breeze and watch the crowd." (Courtesy Bob Basford.)

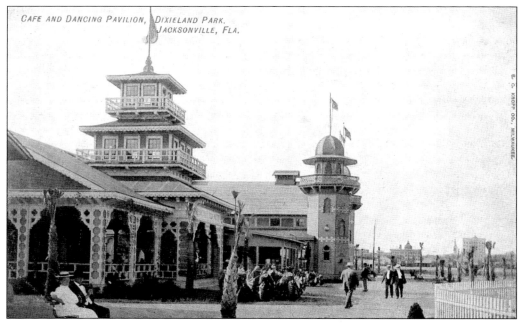

The South Jacksonville Steam Ferry Company developed the riverfront Dixieland Park. After the park folded, another company, the Jacksonville Ferry and Land Company, took over the ferry franchise and replaced Dixieland Park with a dance pavilion, an indoor swimming pool, and a skating rink. Jacksonville's ferry business prospered until the opening of the first "highway bridge" across the St. Johns River on July 1, 1921.

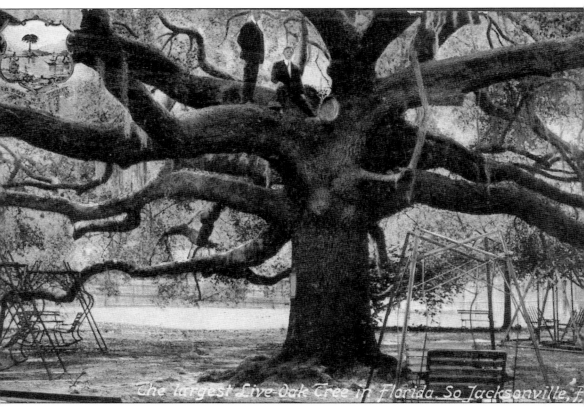

The largest Live-Oak Tree in Florida, So Jacksonville, F

This giant live oak tree, now known as the "Treaty Oak," has ruled for centuries in its South Jacksonville location near the river. The tree was a centerpiece of Dixieland Park, whose proprietors draped it in electric lights and (probably falsely) called the area around the tree "Osceola's favorite camp ground." The grounds surrounding this heroic tree are now known as Jessie Ball duPont Park because of Mrs. Alfred I. duPont's generosity in purchasing the tree's home and donating it to the City of Jacksonville. The card is postmarked January 28, 1911.

Ten

THE ALLIGATOR BORDER SERIES

A lligator Border postcards were published by S. Langsdorff & Co. of New York. Printed in Germany, the printing and color quality are exceptional. Each card featured the same trio of smiling alligators surrounding a different image. The alligators were further accented by an embossing process that raised them above the rest of the card. Hundreds of different Florida views were published; and these cards are much prized by present-day collectors. A selection of Jacksonville views follows. One notes that the images depicted by the Alligator Border postcards are not unique; it is the artistry of the cards that distinguished them.

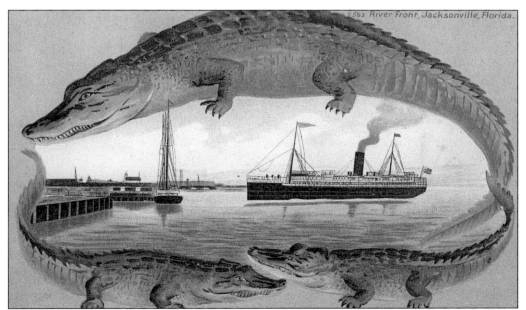

A Clyde Line steamer approaches the Jacksonville berth it shares with sailing ships. (See pages 16 through 18 for accounts of the Clyde Line.)

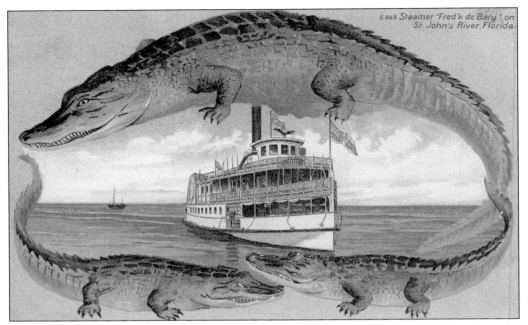

The steamer *Frederick DeBary* on the St. Johns River. No less than three American flags show the patriotism that permeated the vessel or—more likely—the paintbrush of the artist responsible for this postcard. (See page 19.)

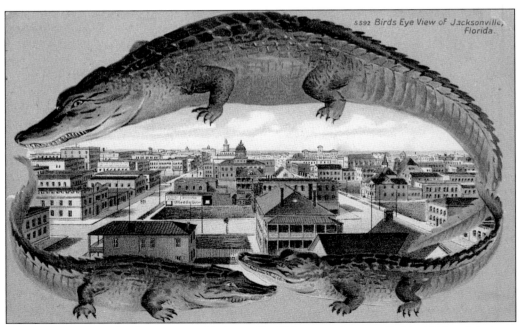

This postcard gives a bird's-eye view of Jacksonville. This postcard was mailed in 1909 and depicts a view similar to the card shown on page 25.

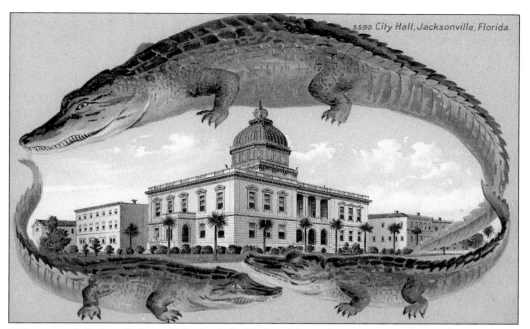

This postcard displays Jacksonville's city hall. Designed by architect Henry Klutho, the city hall is depicted and described on page 35.

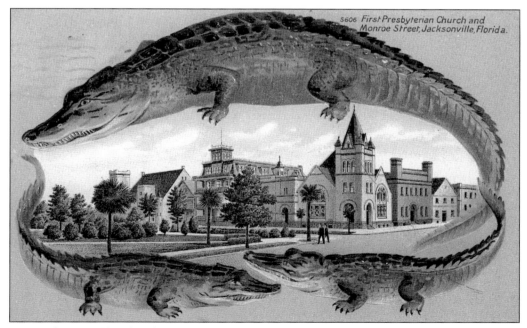

First Presbyterian Church and Monroe Street are shown above. Another view and account of this church appears on page 68.

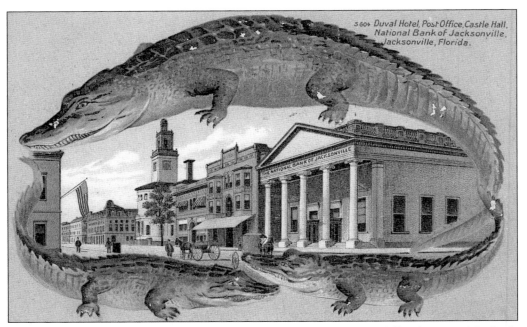

This view shows Duval Hotel (see pages 51 and 52), the United States Post Office (see page 36), Castle Hall, and National Bank of Jacksonville (see page 32).

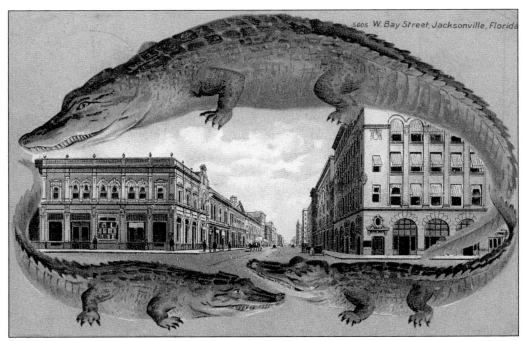

West Bay Street (see pages 24, 27–29) is shown in the postcard above. The 1908 writer says, "My dear niece—I am once more down in the warm country fishing for alligators and health."

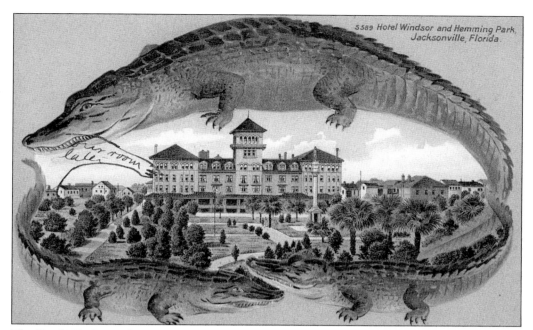

The Hotel Windsor and Hemming Park are seen here, and similar images appear on pages 58 and 59. This March, 1908 tourist marvels to the folks back in Saco, Maine about the "warm and balmy air; flowers and trees in bloom and people dressed as in summer."

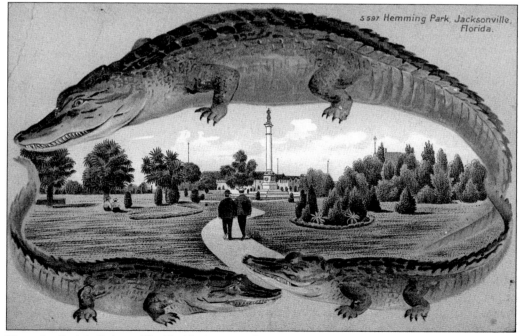

Hemming Park in Jacksonville, Florida, is seen is this *c.* 1908 postcard (see pages 73 and 74).

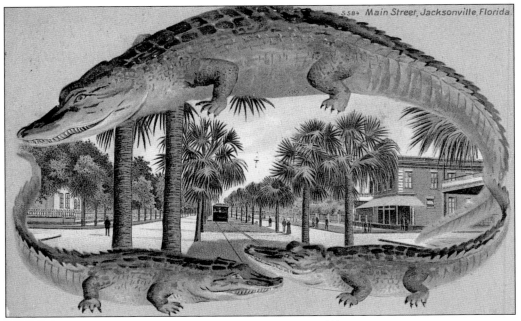

This view shows Main Street, *c.* 1908. (For an account, see page 81.)

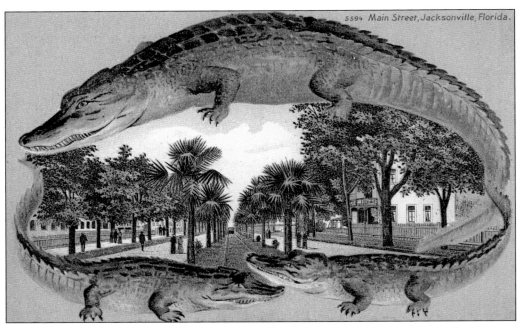

Another *c.* 1908 view of Main Street is seen above. Automobiles have yet to sully this idyllic promenade; however, John Einig had devised and built Jacksonville's first autocar in 1896. "The motor was a small steam engine that threw out a blinding cloud of steam when running and made a noise that caused it to be known as 'Einig's Chug-Chug Wagon'." (T. Frederick Davis.)

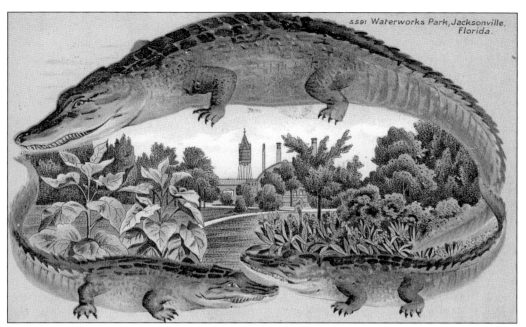

Waterworks Park is shown above. Other Waterworks Park views are shown on pages 76 and 77. This December tourist from Ohio writes home that Jacksonville's temperature is 30 degrees, and they are "going farther south in the morning."

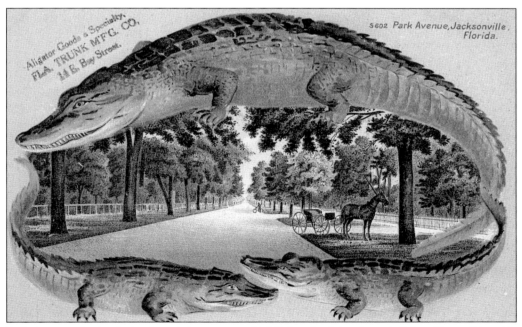

Park Avenue, the lovely boulevard above, was a highlight of a drive through Riverside-to-Riverside Park (see page 87).

One of Riverside Park's five lakes (see pages 79 and 80) is shown above.

Another view of Riverside Park is depicted above.

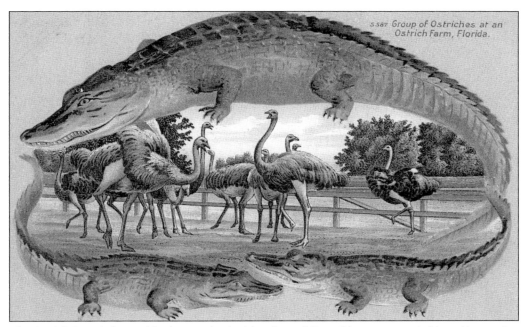

The Ostrich Farm is featured in chapter nine in this volume. "One of the most remarkable and interesting sights to be seen in the United States . . ." (Florida Ostrich Farm brochure.)

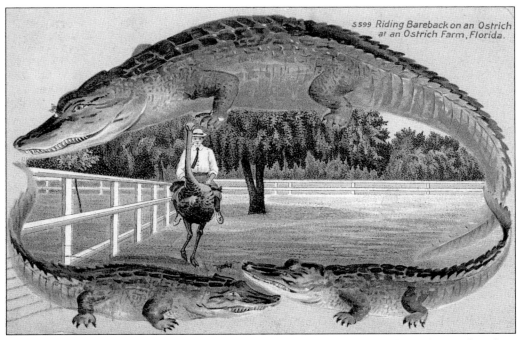

A man enjoys riding bareback at the Ostrich Farm. (This ostrich enjoys a more leisurely pace than those shown in the similar card on page 110.)

AFTERWORD

The Jacksonville Historical Society has been in continuous operation since May 1929. The principal mission has been to educate the citizens of Northeast Florida on the colorful history and heritage of the area and to encourage the preservation of that heritage. From the beginning, the JHS held quarterly lecture meetings with speakers on topics of local historical interest. The society has also long published newsletters and scholarly journals.

In the past decade, the society expanded programs and activities to meet the growing demands for history information in Northeast Florida. The Jacksonville Historical Center, located on the Southbank Riverwalk, was created in a public/private partnership with the city. The free admission historical center serves thousands of visitors, residents, and schoolchildren annually.

In 1994, the JHS launched a campaign to restore historic Old St. Andrews Church, the only major downtown church to survive Jacksonville's 1901 Fire. The restoration project began early in 1997, and was completed in the spring of 1998. During calendar 2000, the society produced and began to screen in St. Andrews a major film production on the city's history.

Recent projects undertaken by the organization include a permanent photograph collection for the city hall at St. James, the inception of history tours of city hall at St. James, and the overseeing of the installation of a permanent history exhibit in the new city hall. The society cooperated with the Jacksonville Museum of Science and History for the extensive "Currents of Time" exhibit. In 2000, the Jacksonville Historical Society saved East Jacksonville's James E. Merrill House from demolition and has begun an ambitious restoration of this home that may date from the 1860s.

The society was instrumental in obtaining city government sponsorship and funding of a major outdoor sculpture to commemorate the centennial of Jacksonville's Great Fire of 1901; the historical society will also collaborate on a book commemorating that centennial.

Other society projects have included two local history volumes: joint publication of a book commemorating the centennial of the Jacksonville Bar Association (1997) and publication of a book to commemorate the opening of the city hall at St. James (1997). The historical society is also contemplating a series of commemorative Jacksonville plates.

The archives of the Jacksonville Historical Society preserve and maintain important local research and house a collection containing thousands of items. The collection includes rare North Florida papers, documents, books, records, and photographs. The archives are located in space provided by Jacksonville University and are available (by appointment) free of charge.

The Jacksonville Historical Society encourages the public to become members and be actively involved in its ventures.

BIBLIOGRAPHY

Baker, George E. *Jacksonville: Riverport—Seaport*. Columbia, South Carolina: University of South Carolina Press, 1992.

Bothwell, Dick. *The Great Outdoors Book of Alligators and Other Crocodilia*. St. Petersburg, Florida: Great Outdoors Publishing Co., 1962.

Broward, Robert C. *A Prairie School Masterpiece*. Jacksonville, Florida: Jacksonville Historical Society, 1997.

Clyde Line. Promotional brochure, *c*. 1900.

Davis, Frederick. *History of Jacksonville, Florida and Vicinity, 1513 to 1924*. Jacksonville, Florida: Mike Blauer d/b/a San Marco Bookstore, 1971 San Marco Boulevard, Jacksonville, Florida 32207 (1925, Reprinted 1990).

The Encyclopedia Americana. 1959 edition. New York: Americana Corporation, 1959.

Florida Ostrich Farm Promotional Brochures. C. 1905.

Foley, Bill. "Golden Age of Big Hotels Disappears." *Florida Times Union*. February 21, 1998.

Foley, Bill. "Ostriches in Their Own 'Fairyland'." *The River Bend Review Supplement to the* Florida Times
 Union. January 5, 2000.

Gilbert, Martin. *The First World War, A Complete History*. New York: Henry Holt and Company, 1994.

Graff, Mary. *Mandarin on the St. Johns*. Gainesville, Florida: University of Florida Press, 1953.

Keegan, John. *The First World War*. New York: Alfred A. Knopf, 1999.

McClintock, John. "A Short History of the Postcard in the United States." *Postcard Collector Magazine*. January 1999. Dubuque, Iowa: Antique Trader Publications.

Mueller, Edward A. *St. Johns River Steamboats*. Jacksonville, Florida: Edward A. Mueller, 1986.

Ross, Charles A. *Crocodiles and Alligators*. New York: Facts on File, Inc., 1989.

Stowe, Harriet Beecher. *Palmetto Leaves*, Boston: James R. Osgood & Company, 1873.

Ward, James Robertson. *Old Hickory's Town*. Jacksonville, Florida: Old Hickory's Town Incorporated, 1985.

Wood, Wayne. *Jacksonville's Architectural Heritage—Landmark for the Future*. Jacksonville, Florida: University of North Florida Press, 1989.